Calligraphy of the Middle Ages and How to Do It

.

Calligraphy of the Middle Ages and How to Do It

Marc Drogin

DOVER PUBLICATIONS, INC.
Mineola, New York

Bibliographical Note

This Dover edition, first published in 1998, is a slightly altered republica-
tion of the work originally published in 1983 by Taplinger Publishing
Company, New York, under the title *Yours Truly, King Arthur.* The list of sup-
plies has been deleted.

Library of Congress Cataloging-in-Publication Data

Drogin, Marc.
　　[Yours truly, King Arthur]
　　Calligraphy of the Middle Ages and how to do it / by Marc Drogin.
　　　　p.　　cm.
　　Originally published: Yours truly, King Arthur. New York : Taplinger
Pub. Co., 1982. Slightly altered.
　　Includes bibliographical references.
　　ISBN 0-486-40205-3 (pbk.)
　　1. Calligraphy.　2. Paleography—Europe, Western.　I. Title.
Z43.D76　1998
745.6'1—dc21　　　　　　　　　　　　　　　　　　　　98-4276
　　　　　　　　　　　　　　　　　　　　　　　　　　　　　　CIP

Manufactured in the United States of America
Dover Publications, Inc., 31 East 2nd Street, Mineola, N.Y. 11501

DEDICATED

To
Annie
& Robbie
& Eric

& Paul Freeman
WHO LEFT IN THE MIDDLE
OF OUR CONVERSATION

CONTENTS

ACKNOWLEDGMENTS

ALL the illustrations and examples of early lettering are the work of medieval scribes. I would like to thank the following institutions for supplying photographs and permitting their publication:

Bamberg, Staatsbibliothek Bamberg, Plate 6
Brussels, Bibliothèque Royale Albert I, Plate 8
Cambridge, Magdalene College Library, Plate 2
Heidelberg, Universitatsbibliothek, Plate 1
London, The British Library, jacket and Plates 3 and 10
New York, The Pierpont Morgan Library, Plate 5
Oxford, The Bodleian Library, Plates 4, 11, 12, and 13
Prague, the University Library, Plate 7
Rome, Biblioteca Apostolica Vaticana, Plate 9

The instructional lettering examples are my own, created with help and criticism from my calligraphic youngsters.

INTRODUCTION

PENNING beautiful medieval letter shapes can be much more than a pastime; it can be an active adventure into history. More graceful and dramatic lettering designs were created during the Middle Ages than at any other time. Medieval calligraphy enjoys great popularity today because, in addition to reviving the romance of times long past, it is an art form that has many modern creative uses.

In order to understand where medieval lettering came from, it is important to know something about the origins of writing itself. Writing has always been an essential component in the development of civilizations. People had to be able to communicate with each other and record events in order for their society to advance—communication through speech was not enough.

The earliest known writing was simple because people just drew pictures of everything they wanted to say. People "wrote" on the walls of caves and, later, on buildings, on rocks, and on bits of bark. Elementary concepts were easy to express in drawings, and the only way you could "misspell" a word was if you couldn't draw clearly enough for others to understand the pictures.

As society became more complex, more sophisticated forms of writing evolved to express the increasing subtleties of language. The ancient Egyptians produced a system of picture writing called hieroglyphics, which contained about seven hundred symbols—quite simple compared to the ancient Chinese writing that comprised thousands of figures. But both systems were cumbersome and time-consuming. Once the appropriate symbols were selected, it took time to draw them (writing is drawing lines, even today), and much space was needed. There had to be a better way, and it came about more than three

thousand years ago, when the Phoenicians created a system that was based not on pictures, but on sounds.

Our eyes receive countless visual impressions every moment, yet the sounds we use to describe what we see and how we feel about it are, by comparison, very few. Nearly every language in the world can be expressed in no more than thirty sounds. It is the way we put the sounds together that allows us to make so many different words with so few "noises."

The Phoenicians' idea for a sound-based writing was probably borrowed in part from the Egyptians, who had used some of the same pictures so often that they were beginning to think of the pictures as the sound of the words they represented. For example, the picture of a dog, representing the word dog, might suggest the sound "D."

Over the centuries the Phoenicians adapted these sound symbols. They could really be called the world's first alphabet, because they gradually became simpler, looking less and less like the original pictures. In the eighth century B.C., the Greeks borrowed the idea from the Phoenicians and, because they had their own way of doing and saying things, changed some of the shapes and used some of the symbols to represent different sounds.

The Etruscans of northern Italy then borrowed those letters and made their own changes. By seven hundred B.C. they had a very usable alphabet of sixteen letters which worked so well that the neighboring Romans appropriated this new way of communicating, along with anything else they could carry away. Then, seeing that the Greeks also had an interesting alphabet, the Romans adopted that as well, combining and altering both to suit themselves until they finally arrived at an alphabet of twenty-three letters—all of which we use today. The three letters the Romans did not have were J, U, and W. They used the letter I in place of J; and since they didn't have a V sound in their language, the letter V represented the sound of U. The W was missing because it, too, was a sound they didn't need. A thousand years ago U became the twenty-fourth letter, and about a hundred years later, people had begun using the sound W and making it with a double U, which would formerly have been a double V. The J is our newest letter, added less than five hundred years ago.

The Roman alphabet has been in use for almost 2,500

years, remaining unchanged in concept. As time passed, however, the way in which the twenty-three original letters and those that came later were shaped, and the people who did the shaping, changed immensely. The period in which much of this happened—the most interesting period in the history of the alphabet—was the Middle Ages.

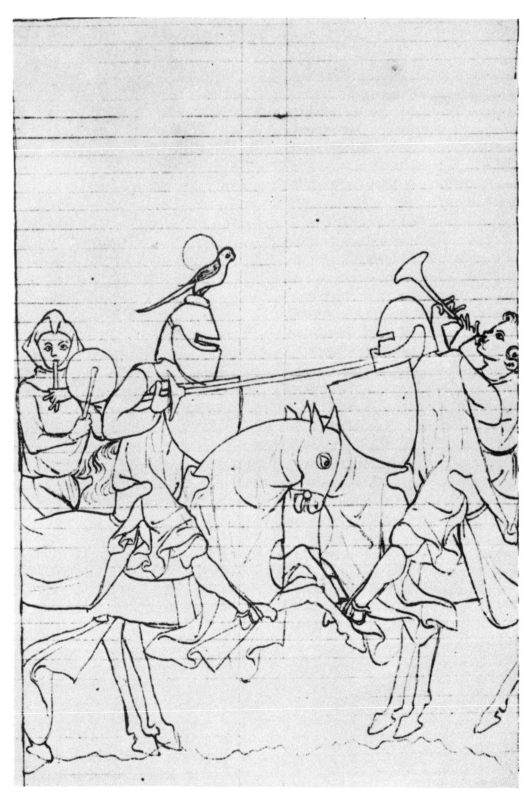

Plate 1. Heidelberg, Universitätsbibliothek, Cod. Pal. Germ. 848, folio 196 recto.

THE MIDDLE AGES

HISTORIANS call the period roughly A.D. 400–1500 the Middle Ages—the time between the end of the great Roman civilization and the rebirth of culture called the Renaissance. The beginning of the Middle Ages (or medieval era) is often called the Dark Ages, but some people use the term to mean most or all of that period in history. All three names, particularly the Dark Ages, evoke images of centuries of dark doings—a time without the light of reason, just laws, or great learning.

Hostility and warfare were a way of life throughout the Middle Ages. Laws were inconsistent, and life was uncertain, usually short and often brutal. Legal decisions were sometimes made in trial by combat, the victor presumed to be right simply because he had won. Even in stable medieval societies, combat was relished but restricted to the elaborate ritual of jousting, shown in Plate 1. A German scribe who lived sometime around 1313–1330 ruled a page with guidelines for margins and two columns of text. He then penciled in what he wanted the artist to paint—two mounted knights spurred on by musical accompaniment. In earlier years the scribe would have illuminated the page himself, but later in the Middle Ages fine illumination was left to specialists.

Another characteristic of the Middle Ages was that people believed in and feared the ever-present nearness of hell and the horrors of everything that could not be explained sensibly and immediately. Legends and misconceptions easily became realities—frightening creatures, some partly human, some combinations of various animals and birds, were known to roam the landscape perpetrating terrible havoc. Among them were dragons of many varieties, one of which was the wyvern, easily rec

ognized because it had wings and two feet and was often seen with its tail knotted. It was common knowledge that the wyvern breathed fire and hungered for human beings. So real to medieval folk were such incredible creatures that it seems perfectly logical to find a wyvern sketched among such equally commonplace animals as cats, dogs, lions, deer, and rabbits. Plate 2 shows such a collection on a page from a scribe's model book. Scribes occasionally had such model books to refer to or copy from when illustrating a page. A page such as this one, produced in England late in the fourteenth century, often had the lines of each drawing pricked with pinholes. Using chalk dust, the scribe could stencil an outline onto the page he was working on and then "connect the dots" to reproduce the creature.

One stabilizing influence during this chaotic and superstition-ridden period was provided by Christian missionaries called monks. Without these men and their followers, all the best knowledge of the ancient world might have been lost during the Dark Ages and civilization as we know it would have been impossible.

These early missionaries who went out from Rome lived alone in the mountains and deserts, testing their faith by depriving themselves of everything but the necessities of life. But in the fifth century the monks and their followers began gathering together in small communities, usually, like most medieval towns, surrounded by walls for safety. The communities were called monasteries. Within the walls they tried to live according to the peaceful and orderly rules of their religion, growing and making everything they needed to live simply and, according to their religion, help the people of the surrounding areas.

This rather new religion had many ideas, many rules, and a fascinating history that the monks believed everyone should study, understand, and pass along to others. Much of it was in the Bible, but as time passed and scholars' thoughts added to the wealth of knowledge, more and more books were needed to contain all this information. When a monastery's population grew large and secure, it often sent some monks farther into the country side to build new monasteries, each of which needed copies of the Bible and all the other books of learning. So in a world of much confusion and little learning, the dozens and then hundreds of monasteries were treasure houses of knowl-

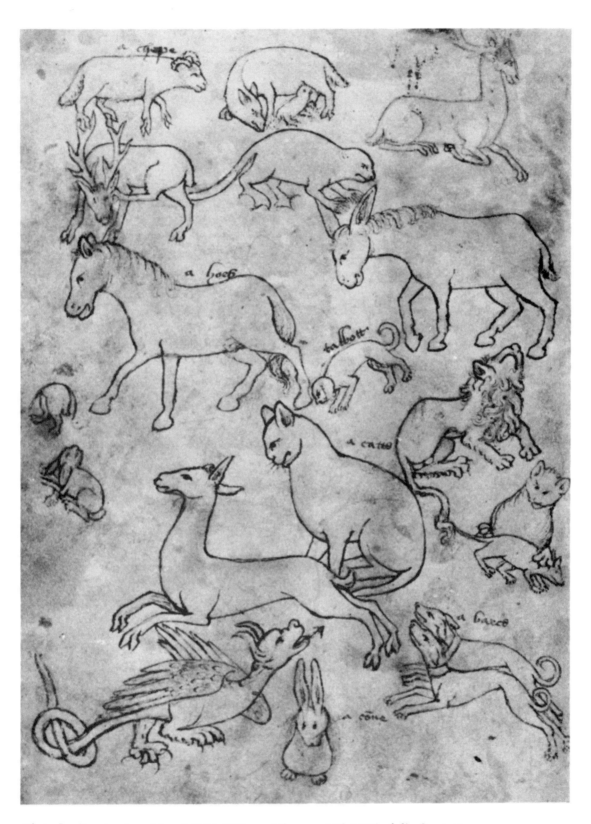

Plate 2. Cambridge, Magdalene College Library, MS 1916, folio 9 verso.

17

edge which demanded enormous amounts of writing and copying.

Monasteries increased their populations by taking in people from the area who wanted to devote their lives to Christianity and spend those lives within the monastic community. The new members were often adults, but there were many children as well. Some were the sons and daughters of poor people who could not support their children, some were orphans, and still others were the children of rich people. Many of the youngsters were sent to the community not to become monks, but to acquire some of their rare knowledge. The new members, older or younger, all had to be educated, and that is why each monastery included a school, usually the only schooling that existed anywhere. And a very important part of that schooling was learning how to write.

THE TEACHING OF WRITING

A child's life in the monastery was much like an adult's—a bunk in the dormitory, beside which were stored a few personal belongings. Day followed day, each organized into times for eating, sleeping, singing in the chapel services, praying, and doing whatever one could to help with tasks. Playtime was limited, rules were strict, and punishment was frequent.

In the few hours of school each day the first thing one had to learn was the alphabet—twenty-three peculiar marks, each with its own name—not an easy task to begin with.

Some teaching monks, to make the task easier, made a learning game of it. They took all the letters of the alphabet and used them in a sentence. It didn't have to make much sense (it's not easy to make up a sentence short enough to remember and long enough to include every letter), but there were several favorites. Today we all know "The quick brown fox jumps over the lazy dog." That is an "abecedarian" sentence containing every letter of the alphabet. Just as familiar to the students of the Middle Ages were sentences in Latin like the following:

Te canit adcelebratque polus rex gazifer hymnis

which, if you really tried to make sense of it, might be worked out to

The hymn, oh, treasure-bearing king, sings
of you, and the North Pole also honors you.

Another was

Trans zephyrique globum scandunt tua facta per axem,

which can be translated to read

Your fortunes rise across the earth and
throughout the regions of the zephyr.

Actually, these Latin sentences use only twenty-two letters of the alphabet since, at the time, **K** was sort of an optional letter, employed only when writing Greek words.

With the teaching monk's help, students studied these sentences over and over, watching the monk write them again and again, and getting used to which letter meant which sound. When the students were ready to start writing the letters, the monk gave each a sheet on which the letters were written and a writing instrument with which to trace each letter. Another method was to give each student a tablet, much like a small slate with a slightly raised wooden rim around it. Instead of a slate surface, though, it was filled with a thin layer of wax. With a pointed stick, called a stylus, the monk would letter out an alphabet or write an abecedarian sentence by scratching it in the wax, and the student would then move the point of the stylus in the grooves of each letter, learning their shapes. If he had the time or the skill, the teacher might carve the letters on a wooden board so that the students could move their "pens" in the grooves.

Once his students were familiar with the shapes of the letters, the monk distributed material to write on, and pens and ink to write with—all things that, sometime during their endless days in the monastery, the students had helped to produce. Since many supplies were hard to come by, wax tablets were most popular. At the end of a lesson

the wax could be melted smooth and the tablet was ready to use again.

Now the students learned to form the letter shapes themselves, keeping in mind the ductus (the sequence of strokes and the direction of each) their teacher had used. This was an important part of learning to shape letters, because the students were not being trained as artists, free to create in a timeless environment, but as scribes needed to write and copy books (the word "scribe" comes from the Latin *scribere*, meaning to write). Students had to learn how to form each letter in such a way that (a) it was done as quickly as possible, yet (b) with concern for visual appeal, and (c) in such a manner that the pen completed its task near or moving toward where the next letter would begin. Efficiency was often more important than artistry, so the students labored to imitate the ductus used by the teacher, who had himself learned to write by imitating his instructor.

The teacher was absolute ruler in his domain, and students who misbehaved or fell below expectations were often punished swiftly, harshly, and in full view of the class as a warning to others. Some teachers wielded "palmers," sticks with round, flattened heads with which to slap students' palms. More common, as seen in Plate 3 within a capital letter **C,** was the whipping of a student with birch branches. This birching scene is from an English manuscript of the mid-fourteenth century, at which time monasteries had long since ceased to be the major source of elementary education.

The teaching monks knew learning was difficult and concentration, especially in young children, hard to maintain, so the monks recounted stories emphasizing the importance of writing. They told students about the famous monks who had written beautifully, who had written and copied enormous numbers of books, and who had been permitted, because of their ability, to lead their fellow monks out into the world to establish new monasteries.

A favorite story concerned the scribe who seemed very much like the young students in spirit; he couldn't quite behave and follow orders without occasional lapses. But he could write well, and he loved to copy books. When he grew old and died, the books he had produced represented his only worthy accomplishment in life.

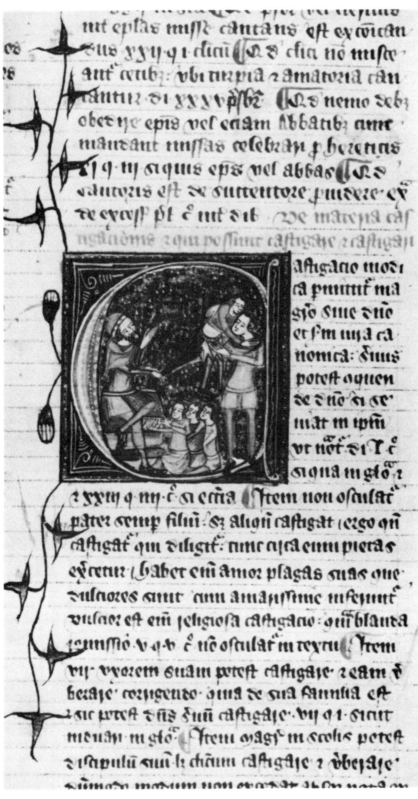

Plate 3. London, British Library, MS Royal 6 EVI, folio 214 recto.

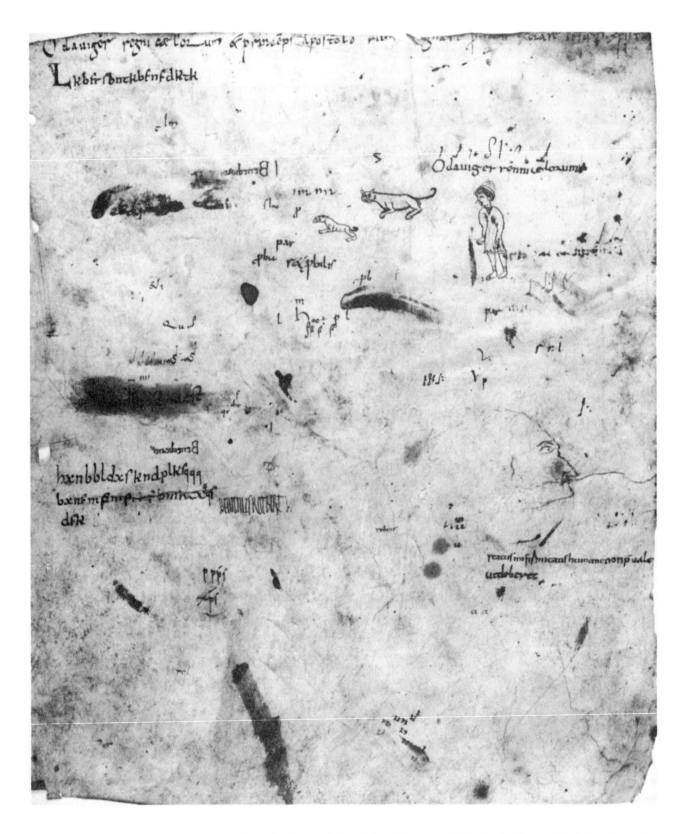

Plate 4. Oxford, Bodleian Library, MS Auct. T. 2. 28, folio 43 recto.

22

When the scribe's soul came before God for judgment, all the demons shouted out the many bad things he had done and insisted that his soul be condemned to spend forever in hell. But all the angels cried out that such a marvelous collection of books had earned the scribe's soul an eternity in heaven. After some noisy confusion, it was decided that the good should be weighed against the bad; the demons would count up every sin he had ever committed or even thought about committing, and the angels would count every letter on every page of every book he had produced. Whichever was the greater would decide his fate.

When the counting was completed, the result was astonishing. During his entire life the scribe had written just one letter more than the number of bad things he had done or considered doing. But that one letter was enough for him to enter heaven.

Finally, to remind us how little things change, let us look at Plate 4. Children learning to write thousands of years ago practiced on whatever was handy. Early Greek and Roman youngsters scratched letters on bricks and broken pieces of pottery; in the Middle Ages they were equally resourceful. One schoolboy in about the year 900 found this page in the back of a book. He practiced for a bit with his lettering, making musical symbols above some letters since he was also being taught to sing at services. Then he got bored and did a bit of writing backwards. At some point he decided it was more fun drawing the monastery cat apparently chasing the monastery dog, and even a sketch of one of his classmates or perhaps himself. Because this page was part of a book, he was surely punished for writing in it, but it has survived more than a thousand years. I do not believe it has ever been photographed before.

THE SCRIBES & THEIR WORK

Those students who chose to stay when their schooling was completed were ceremoniously made part of the community and became monks. From then on their lives were wholly devoted to their community and their work.

In the early monasteries, everyone shared all the labor, each taking his turn at every task. But when a monastery grew in size and wealth, it was possible to divide the work more productively, with each member doing what he was best at. Those with ability as scribes were thus freed of field labor, cleaning, and other such chores to work in the writing room, called a scriptorium.

Since community ideals favored simplicity and considered most comforts dangerous temptations, the scriptorium was unheated, the stools were designed without restful backs, and no candles were allowed. The light the candles would have provided was outweighed by the danger of dripping wax marring the books or flame destroying them. The desks, their tops set at steep angles, were usually arranged to catch the light from the few small windows. In order to gain maximum light for as long as possible, some scriptoria were actually simple arrangements of desks set beneath the windows of an inner wall of a courtyard, with screens placed between the desks to reduce distractions. For some of the year fresh air was appreciated; at other times it froze the ink and scribes complained that their fingers grew too numb to work.

Early monasteries were often in danger of attack, so what was valued most—particularly the books—was protected in fortresslike towers. Such bastions were topped with bells to ring out the different segments of the day in times of peace, and to sound the alarm when danger arose. The walls were round to deflect boulders, and the windows small to keep out arrows. Often the heavy front door was set, not at ground level, but as high as a man's head from the ground, and reached by a ladder that could be pulled out of reach as the enemy approached. If the enemy did manage to enter, the monks would flee upstairs, pulling the ladders after them to delay pursuers. Most feared was an enemy attacking with fire, for then there was no escape either for the books or the monks. The thirteenth-century artist who drew the picture in Plate 5 probably copied a similar one from a tenth-century manuscript. He didn't draw the protective wall of the scriptorium so that he could show how busy the scribes were in the safety of their tower.

Scribes worked with a great variety of tools and materials, almost all of which they themselves had learned to

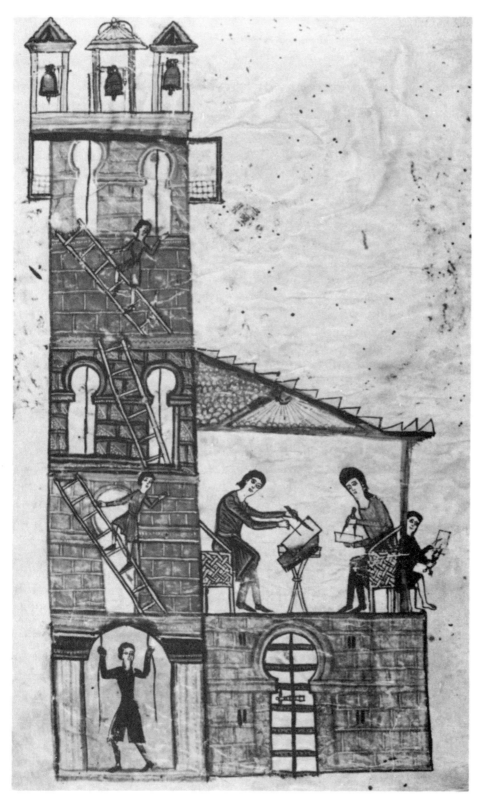

Plate 5. New York, The Pierpont Morgan Library, MS 129, folio 183.

25

prepare. There were compasses (for arcs and circles), metal rules (along which a dull knife was scraped to make guidelines for lettering), leads (to mark drawings, as pencils were not yet known), feather quills, brushes, styluses and wax tablets, knives (to cut quills and hold down the often not-quite-flat writing material), pots of inks of various colors, paints, and sheets of parchment.

A scribe might be artful about what he did and enjoy his craft, but he had to do it quickly and get on to the next job. Every mechanical aid was welcome to improve and to speed the work. Scribes always ruled guidelines to keep lettering even and straight. Tablet and stylus were at hand to make notes, to plan the design of a page, or to test a line of writing for length. In the early Middle Ages it is quite likely that the scribes not only did all the writing, but also painted the colorful chapter headings and even designed and painted the huge elaborate capital letters filled with pictures. In the later Middle Ages, these tasks were often left to specialists: rubricators (from the Latin for red, referring to the large red letters), and illuminators, who painted pictures or elaborate page borders, and whose use of gold was said to light up or illuminate the page—hence their name.

By the time scriptoria had been established in monasteries in Europe and Great Britain, the use of papyrus (a writing material made from strips of marshland reeds) had been abandoned in favor of parchment, made from the cleaned and dried skins of animals. These skins were strong and tough, easy to handle, and certain to last for centuries. The use of paper did not become popular until the end of the Middle Ages because it was fragile, expensive, and believed invented and manufactured by "infidels" from the Middle East.

Pens and brushes, as in more ancient times, were cut from reeds, but early in the Middle Ages the quill, cut from the large wing-feathers of birds, gained favor. Parchment and quill became so popular that paper did not come into much use until about five hundred years ago, and quills were in standard use as recently as a century ago.

In the twelfth century, a German scribe illustrated a book showing the various stages in creating a manuscript. Plate 6 shows the nine steps that follow after the scribe has

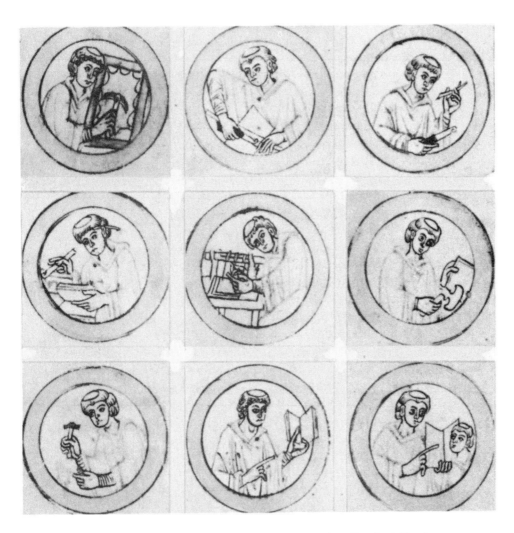

Plate 6. Bamberg, Staatsbibliothek, MSC Patr. 5 (B. II. 5), folio 1 verso.

planned his book on wax tablets. He is seen finishing the preparation of the parchment, stretching it on a frame, and scraping it clean and smooth. Then it is cut into proper size pages, and the quill is cut carefully to the right point width and angle for the size and kind of lettering planned. The scribe then works on the book, occasionally tucking the quill behind his ear and using the knife to scrape away errors or mix ink or paint. When the book is completed, a cover is made, the book inserted, pages trimmed, and hinges or a clasp made to secure it. Then the scribe holds the book aloft, pointing to the finished product. But the true value of a book lay in what could be accomplished with it. The illustrations end by showing the purpose of all the work—to be able to teach others and share knowledge.

Monastery scribes helped to spread their religion across Europe in the early Middle Ages. Some of these monks and nuns became famous for the products of their artistry which, today, along with the work of thousands of scribes whose names were never remembered, are the treasures of libraries, museums, and monasteries in many parts of the world. But they were not the only scribes.

From about the eighth century onward, scribes who were neither monks nor nuns became an increasingly familiar sight. True, most were trained in monastery schools, and some had even gone on to join communities, but at some point, for their own reasons, they preferred returning to the outside world.

Work was available for such scribes because society required many varieties of writing services. Royal and legal courts needed scribes to keep official records, merchants needed accounts kept, and so on. Even monasteries, the source of scribes, occasionally sought outside help. No sooner had a contagious illness or an enemy force left a monastery depleted in membership, than word might go out that scriptorium help was needed.

The independent scribe who took such monastery work was usually paid with the customary simple food and humble place to sleep. If he worked elsewhere, he might be paid in the same way or given bread by the baker, meat by the butcher, or whatever the employer was willing to trade. Some received payment in cash as well, but not a great deal; the lowliest soldier in the army earned more than the independent scribe.

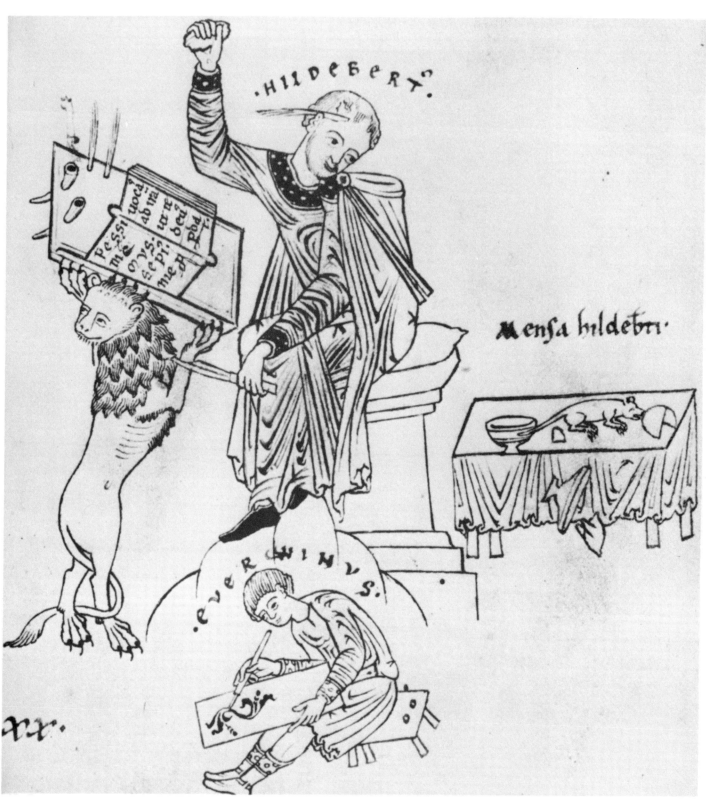

Plate 7. Prague, Cathedral Library, MS Kap. A21. 1.

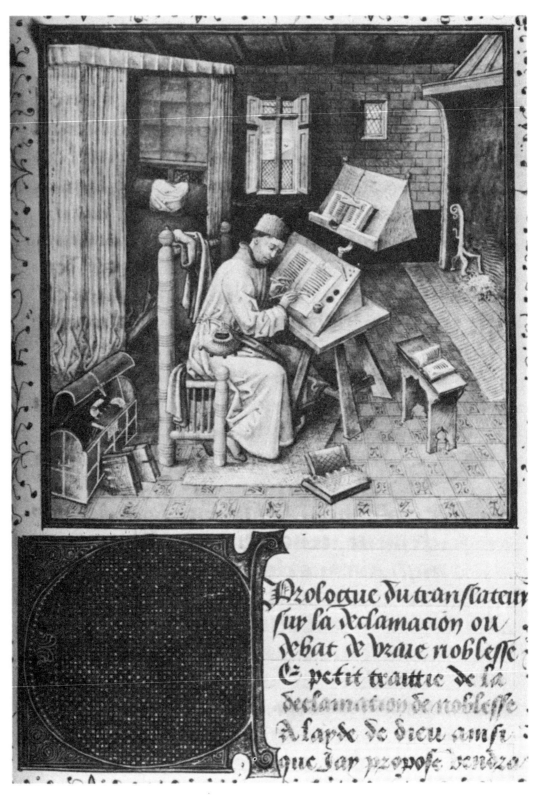

Plate 8. Brussels, Bibliothèque Royale Albert 1, MS 9278-80, folio 10 recto.

It was often a precarious existence, lacking both in prestige and income, and such scribes often taught youngsters their craft or took them on as unpaid apprentices to help as they learned. Hildebertus, an independent scribe in Bohemia in the twelfth century, ended a manuscript by drawing a self-portrait (Plate 7) that tells something about how he lived (so poorly that he and a local mouse vied for lunch). At least we know that a sense of humor buoyed his existence, or he would not have troubled to sketch this whimsical picture. "Pessime mus," he says (penning the words on the pages on his worktable), "saepe me provocas ad iram: ut te deus perdat!" ("Wretched mouse, provoking me so often to anger; may God bring you to perdition.") And with that he aims a sponge at the mouse trying to steal the cheese that represented Hildebertus' meal (for he had written above the table "mensa Hildebertus," or "Hildebertus' food"). This attack is obviously only the latest of many, for the scribe's assistant, Everwinus, busy practicing a scroll design, doesn't even take notice. Hildebertus has the customary knife, quill (behind his ear), and two inks (probably red and black) in hollowed horns, as well as two spare quills.

On the other hand, there were famous scribes who worked for princes and kings and who were treated as important artists. A few who were excellent and famous were hired to work on special tasks, for collecting beautifully written and illuminated books had become a passion among the very rich. Rooms were set aside as libraries in homes and the finest scribes, rubricators, and illuminators sought to produce books for private collections or as gifts to Church and King. When Philip the Good ruled the Netherlands he had his own expert calligrapher, Jean Mielot, to whom he probably gave a private working and sleeping room in one of his castles. An equally famous illuminator, Jean le Tavernier of Bruges, painted a manuscript illustration showing Jean Mielot making a copy from a special book perched above his worktable (Plate 8). Notice the handy ink holders, the holes in the desk to keep other quills and brushes near, and the hanging weight to hold the little book open without damaging it. By showing the large room with big fireplace, comfortable bed, and sturdy book trunk (many libraries were simply storage containers), the illuminator made clear how highly Philip valued his scribe.

But employment as a court scribe did not guarantee a comfortable existence. One expert scribe was so admired that he was given a position in one of the king's castles. But the king, with many residences in his domain, didn't visit that castle often, and the scribe finally had to send his wife out to run a shop in the market so that they could make ends meet until the king happened by and, with luck, provided some work.

From about the beginning of the twelfth century, when life in general became more settled, towns and cities grew and society and commerce became more complex. The need for education grew and, in a world at peace, more people were inclined to pursue it. This resulted in students gathering in major cities, intent on learning from resident scholars. In this way universities began, and more students were attracted. Because university students required textbooks and copies of classic works, the demand for scribes increased dramatically. Companies of scribes gathered in workshops near every university, spending long hours in copying. Working together or self-employed, they joined in guilds, somewhat like our modern unions, and were able to demand higher wages, which forced up the cost of books, sometimes beyond what students could afford. Thus teachers frequently began their school courses by reciting the entire textbook to allow students to copy it down for themselves. Other students whose teachers did not want to spend their time in this way rented parts of the textbooks from bookstores, made their own copies from them by working late into the night, and then rented the next sections, and so on.

As time went on and the complexity of life increased, cities expanded, with country people constantly arriving to take jobs in shops and businesses. Many of these jobs required the ability to read and write. But who was there to provide this basic education?

The need was answered by another kind of scribe, seen most often in the last century of the Middle Ages. He was the writing master, a scribe who could teach the many different styles of lettering needed for different occupations.

Some writing masters set up small, permanent schools in heavily populated areas, but others preferred traveling across the land, teaching as they went. Such a writing

master might arrive in town, move into the local inn, and then post signs on the door of the inn, the church, and on the walls of the marketplace, announcing that he had arrived to teach writing to anyone able to pay the fee—which he promised would be higher for the rich and less for the poor. The writing master usually lettered his signs in several different styles to show that he could teach whatever styles of writing were desired. Some signs urged prospects to decide in a hurry before the teacher packed up and moved on to another town. One writing master went so far as to assert that people who didn't know how to write could never hope for a better life and would probably wind up in jail, but those clever enough to study with him might become rich and famous and admired by all.

The invention of the printing press in the mid-fifteenth century changed the scribes' age-old way of life. While many found there was little work, some took their knowledge and went to work for printers, others became teachers, and a few wrote books on how to letter beautifully. As more people learned to write, fewer scribes were needed, and the great age came to an end.

Today, writing is so basic a skill that few give it much thought and even fewer stop to think that beautiful writing is really an artistic achievement. And while some people have studied the medieval styles, few realize that the best way to learn is to know who the scribes were and how they wrote.

LEARNING TO WRITE

TO BEGIN lettering in medieval fashion, you should first know a few basic techniques that were used by the scribes of that time. While they worked with quills on parchment, it is easier to learn with pens on paper. You need a fountain pen with a flat nib (point). Ruled paper would be good, but graph paper even better; the thin horizontal and vertical lines act as a constant reminder of consistent letter size and angle. And you need a flat board or large book to serve as a tilted writing surface.

1. Grasp the pen as you normally do, but hold it almost upright instead of tilted back. Rest your hand on the paper, supported by part of your small finger and the padded edge of your palm. Rest it lightly so that your hand can slide along as you work.

2. Medieval scribes always worked with their writing surface at an angle. The best angle is 45 degrees, halfway between flat and straight up. Set the board on a table and prop it up with a few books, or sit back a bit, set the bottom edge of the board in your lap, and let it lean against the edge of the table. I like to work while sitting in an easy chair, so I cross one leg over the other and that keeps the board in my lap at about 45 degrees.

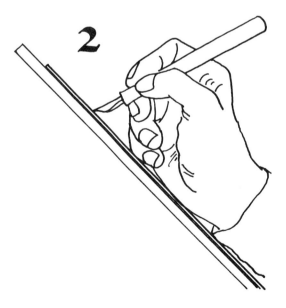

3. The paper, taped or clipped to the board, should be straight and directly in front of you, but if you are used to

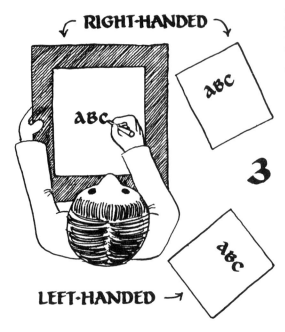

RIGHT-HANDED

LEFT-HANDED

having your paper tilted, a slight tilt is all right. If you are left-handed, it is best to tilt the paper quite a bit—as far as you need to turn it so that you can write from below the line of lettering. The left-handed style of writing where the hand is above the lettering makes calligraphy almost impossible.

The lines you draw should be made to the left of your hand and about as high up on the paper as the top of your hand. Don't twist your hand to try to hold it directly below your writing.

4. Hold the nib on the paper so that the end of the nib is at 45 degrees to the line you are writing on. You will be making the thinnest possible stroke (A) when you move the nib along that 45-degree line. When you pull the nib in a line perpendicular to that 45-degree line, you will be making the thickest possible stroke (B). All the beautiful letter designs formed by thick and thin strokes, and the graceful changes in curved strokes as a line thickens and then thins are created automatically by the nib if you keep the angle constant, in this case at 45 degrees. Notice that the nib can slide in either direction along its tip, and it can be pulled in every direction, but it should not be pushed. So to pen a circle, for instance, imagine it as the face of a clock. The first stroke begins at eleven and swings counterclockwise to five; the second stroke begins at eleven and completes the circle with a clockwise swing.

This technique of keeping the nib at a constant angle is known as the "fixed-pen" style. Many medieval scribes who combined a taste for graceful shapes and nimble finger movement produced more calligraphic work by occasionally changing the nib angle. This technique is called "manipulated pen" or "twist stoke."

All scribes felt that their vertical strokes were prettier if the top and bottom of the stroke were wider than the middle. Sometimes the serif, as this wide area is known, was merely a broad line across the beginning and the end of the vertical stroke, as in the capital letter **I**. Sometimes, instead of starting with a wide line and then suddenly changing to a narrower vertical stroke, the change was inked more gradually. Fixed-pen scribes accomplished this by penning two or more strokes. But twist-stroke scribes had a way of doing this in a single stroke.

5. To explain it, here first is an exaggerated example. The scribe began with the nib (A) horizontal and traveling to the right. Then he turned the nib to 45 degrees (B) to make the vertical line, and he finished by returning the nib to the horizontal (C) and traveling to the right. With the changes of angle made abruptly, the result each time is an unpleasant bump. So this had to be solved.

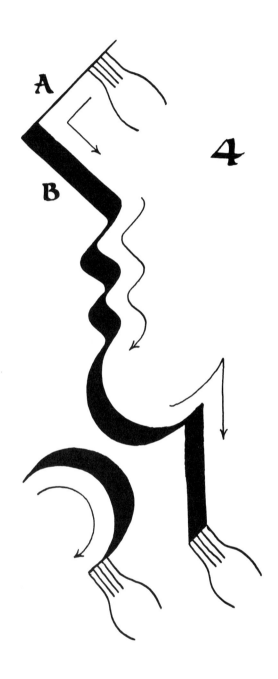

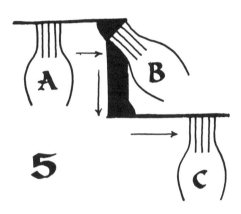

6. The solution was to think ahead. As the horizontal nib travels to the right (A), it is already swinging toward 45 degrees. As the nib starts downward (B), it is at the same time finishing the swing to 45 degrees—soon enough so that most of the downward travel is at 45 degrees. As the nib nears the bottom, the swing back to horizontal begins, and it is completed (C) as the nib moves away to the right.

When you learn to do this smoothly, with the nib never actually stopping from beginning to end, you can (D) stop making the long start and finish. With the nib never stopping and the swings performed smoothly, a graceful curve is created at the top left and bottom right of the stroke.

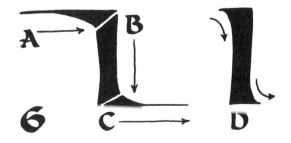

7. This technique was also used to enhance curved strokes. The top of the letter **C**, for instance, can be very graceful when you use the fixed-pen technique. But if you use the twist-stroke technique and, near the end of the stroke, twist the nib to a steeper angle—by swinging the left corner of the nib downward—the stroke ends with a broader, more dramatic finish.

With a little practice, holding the pen almost upright, the paper at an angle, the nib at a fixed angle for most work and swinging smoothly for serifs, you have the basic skills of a medieval scribe.

In each of the four chapters that follow, you will read about a famous man whose name recalls a great period of the past. In the chapter devoted to each man, you will see the way the finest lettering of his period looked, you will learn how to form the letters as the scribes of the period did, and you will learn how the scribes of each period handled paragraphing, punctuation, capitalization, and overall page design. Also presented are ideas on how the scripts may be used today.

SINCERELY YOVRS, JVLIVS CAESAR

THE MAN

JULIUS Caesar was born in 100 B.C. and died in 44 B.C., more than half a century before Christianity began and almost five hundred years before the Middle Ages. But he helped fashion an empire which was a very important part of the history of the early Middle Ages, a period in which he was greatly admired and his life and books studied and discussed. The scripts in which he and his contemporaries wrote were the ones in use when the Middle Ages began, and they were the inspiration for all the styles of writing from the beginning of the medieval era to the present.

Caesar is probably the most famous Roman of the Roman Empire. While he was a brave warrior, he was also an excellent statesman, scholar, author, and poet. History has little detail about his writing training. The son of rich and noble parents, he probably took lessons that were much like those given the students in later monastery schools. But in Caesar's case the tablet would have been finely made, the stylus of metal, the teacher privately hired, the classroom comfortable, and the atmosphere friendly. When he grew up he spent a good deal of his time writing. On campaigns of war he was sometimes seen in the field followed on horseback by one or even two secretaries busy taking down his words.

THE SCRIPT

About a century before Caesar was born, the Romans adopted the reed pen from the Greeks. While Caesar was growing up, these pens were used with sharp points. Late in his lifetime, scribes began cutting their pens with broader nibs, and the strokes they penned varied in thickness. That variation, and the pleasing shapes of the letters, created a highly calligraphic result if care was taken. Paleographers, experts who study the history of writing, have given different names to the various similar styles of writing that were popular in Caesar's time. Almost all of them were cursive, the term used for writing meant to be done rapidly. While the shapes of letters may have changed as the centuries went by, all were familiar as forms of Roman Cursive style.

For instance, a hurried scribe concerned only about speed might not lift the pen after every letter (as in a fourth-century manuscript) with this result:

If he was in a hurry, but still concerned that his writing be readable (as in a second-century manuscript), it might appear:

If it was more important that the letters be graceful than quickly written (as in a first-century manuscript), the result could be:

And finally, if he wanted to write elegantly, no matter how long it took, the lettering was no longer cursive and might look like this version, which first began in very rough form during Caesar's adulthood:

ROMAN

What made it so appealing were two things: first, the great variation between thick and thin strokes and, second, the adoption of the serif, the decorative beginning or ending of a stroke, which the Romans had seen the Greeks using for many years.

As scribes broadened their nibs further and perfected the serif in the early years of the first century A.D., this version became the very calligraphic script called Roman Square Capital.

But it wasn't very useful. Roman Square Capital had to be written with the nib most often almost horizontal, which made lettering slow; it had to be written with great care, which made it slower; and it needed space because it was important and demanded large letters, which made it expensive in terms of parchment or papyrus. So it couldn't be used often. But because it was so dramatic, the scribes refused to give it up entirely. They continued to write in the cursive ways we have seen, with the nib at an angle, but they began trying to shape their letters to look somewhat like Roman Square Capital, and they began to add the easiest sort of serifs they could without slowing down.

We call this half-quick, half-elegant script Roman Rustic. When the Middle Ages began, Roman Rustic was a standard script that would remain important for another century. Many scribes, of course, lettered it without too much concern for beauty, but one scribe took very special care with it. His work, penned in the fourth or fifth century, is a most beautiful example of Roman Rustic. Plate 9 shows most of a page on which he copied some of the words, in Latin, of the great Roman poet Virgil, and the lettering is

ANTARAECIRCVMETCRINISEFFVSASACERDOS·
ERCENTVMTONATOREDEOSEREBVMQVECHAOSQVE·
ERGEMINAMQVEHAECATENTRIAVIRGINISORADIANAE
PARSERATETLATICESSIMVLATOSFONTISAVERNI·
ALICIBVSETMESSAEADIVNAMQVAERVNTVRAENIS
VBENTESHERBAENIGRICVMLACTEVENENI·
QVAERITVRETNASCENTISEQVIDEFRONTEREVVLSVS·
ETMATRIPRAEREPTVSAMOR·
IPSAMOLAMMANIBVSQVEPIISALTARIAIVXTA·
VNVMEXVTAPEDEMVINCLISINVESTERECINCTA·
TESTATVRMORITVRADEOSETCONSCIAFATI
SIDERATVMSIQVODNONAEQVOFOEDEREAMANTIS·
CVRAENVMENHABETIVSTVMQVEMEMORQVEPRECATV
NOXERATETPLACIDVMCARPEBANTFESSASOPOREM
CORPORAPERTERRAS·SILVAEQVETSAEVAQVIERANT
AEQVORACVMMEDIOVOLVVNTVRSIDERALAPSV·
CVMTACETOMNISAGER·PECVDESPICTAEQVEVOLVCRES·
QVAEQVELACVSLATELIQVIDOSQVAEQVEASPERADVMIS
RVRATENENT·SOMNOSPOSITAESVBNOCTESILENTI
ATNONINFELIXANIMIPHOENISSANEC VMQVAM
SOLVITVRINSOMNOSOCVLISAVTPECTORENOCTEM
ACCIPIT·INGEMINANTCVRAERVRSVSQVERESVRGENS
SAEVITIAMOR·MAGNOQVEIRARVMFLVCTVATAESTV·

exactly the size in which the scribe wrote. This script was created from the Roman Cursive, in which Julius Caesar wrote, in imitation of Roman Square Capital, with which Caesar was familiar although he may not have used it. Roman Rustic was still in its infancy when Caesar died—it really developed as a separate and calligraphic script during the first hundred years A.D.

It is not difficult to see why this scribe's hand, meaning his personal style of penning this script, was so striking.

He began with the clever twisting serif at the top of his vertical strokes, but, because Roman Rustic was intended to be written rather quickly, the stroke began with the nib at beyond 45 degrees (A) and then continued almost to 90 degrees (B). Then, on the way down the stroke, he twisted the pen back to 45 degrees (C). This created an appealing vertical shape and left the nib ready to make the diagonal and curved strokes at 45 degrees.

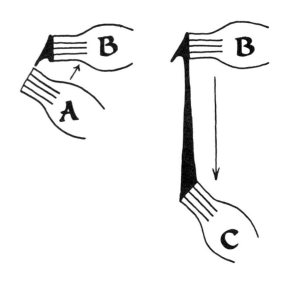

The scribe also chose a very pleasing proportion for his letters, and you will find that a change in the proportion of width to height can greatly alter the appearance of letters.

If you use the same size nib but change the height of your letters, you see that the strokes of short letters seem very heavy and thick, and the strokes of tall letters very thin and light. The scribe whose Roman Rustic is so excellent penned most of his letters about six times as tall as the width of his nib. (As was the practice then, the letters **B**, **F**, and **L** were usually made a little taller than the rest).

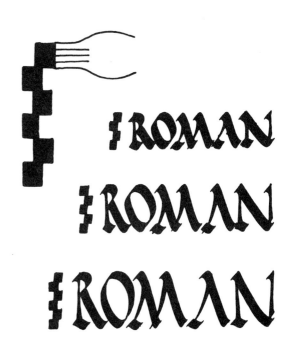

HOW TO DO IT

With the nib you plan to use, make a stack like the one at the right, six nib widths high. If you are using the same grid paper and nib size as those on the following pages,

Plate 9, left. Rome, Biblioteca Apostolica Vaticana, Codex Vaticanus Palatinus 1631 (P), folio 112 verso.

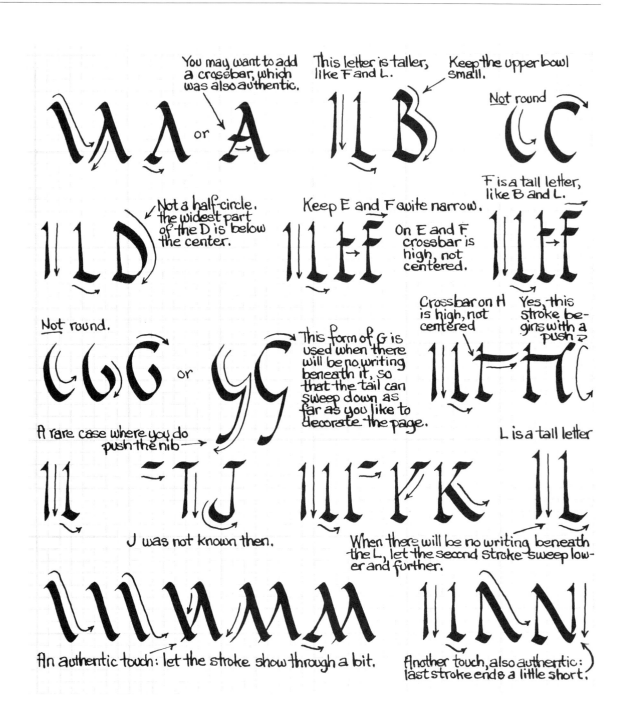

You may want to add a crossbar, which was also authentic.

This letter is taller, like F and L.

Keep the upper bowl small.

Not round

Not a half-circle. The widest part of the D is below the center.

Keep E and F quite narrow.

On E and F crossbar is high, not centered.

F is a tall letter, like B and L.

Not round.

This form of G is used when there will be no writing beneath it, so that the tail can sweep down as far as you like to decorate the page.

Crossbar on H is high, not centered

Yes, this stroke begins with a push

A rare case where you do push the nib

J was not known then.

When there will be no writing beneath the L, let the second stroke sweep lower and further.

L is a tall letter

An authentic touch: let the stroke show through a bit.

Another touch, also authentic: last stroke ends a little short.

Roman Rustic

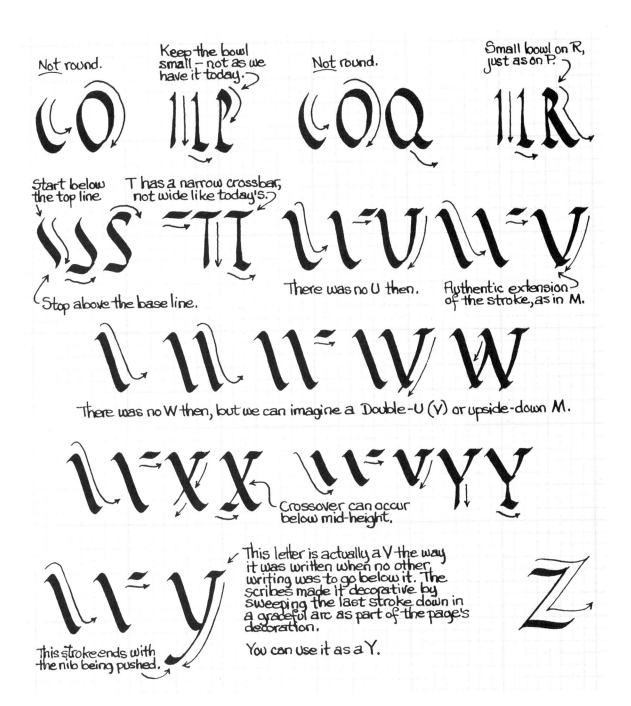

Not round.

Keep the bowl small – not as we have it today.

Not round.

Small bowl on R, just as on P.

Start below the top line

T has a narrow crossbar, not wide like today's.

There was no U then.

Authentic extension of the stroke, as in M.

Stop above the base line.

There was no W then, but we can imagine a Double-U (V) or upside-down M.

Crossover can occur below mid-height.

This letter is actually a V the way it was written when no other writing was to go below it. The scribes made it decorative by sweeping the last stroke down in a graceful arc as part of the page's decoration.

You can use it as a Y.

This stroke ends with the nib being pushed.

you see that a height of six nib widths is nearly five-eighths of an inch. To take advantage of the handy guideline just above it, practice your Roman Rustic at six and a half nib widths or exactly five-eighths of an inch high. Once you have learned the style, letter it four or five or seven nib widths high, all of which are also authentic, and choose your own favorite proportion.

For instance, for a poem or book report title involving humor or gentle emotions, use tall letters with long, graceful strokes. For something exciting, angry, or loud, like an oration, try shorter, heavier letters. They seem strong, as though the words were being shouted.

Pages 44 and 45 show the ductus of each letter in the Roman Rustic alphabet and the letters that the Romans didn't use but which we need today. This ductus is, to the best of my knowledge, the way in which the earliest medieval scribes penned this script. The lettering on these two pages is based on what was most beautiful about the famous scribe's hand, to which are added some little touches admired in some of the many pages written by other Roman Rustic scribes. As you see the examples of other scribes later, you may add some of their techniques to create your own personal hand.

Learning the ductus and practicing the shapes on the preceding pages will teach you Roman Rustic. But don't just study my hand. Each of us sees things just a little differently, and each of us has his or her own preferences for shape and the use of space. Your hand may not move at the same speed mine does, which changes the way the ink flows. All of these things make my Roman Rustic hand mine. You may want to take my advice about how to do it, but the best person to learn from is the medieval scribe himself.

As you practice, keep looking back at his lettering as though he were your real teacher. See how he shaped a letter, see how he squeezed a circle so it would need less space, see how much room he liked to leave between letters and between lines of lettering. When you have learned Roman Rustic this way, it will not be so exactly like the scribe's that one cannot tell the difference, but it will be your personal medieval hand based on instructions from your own medieval teacher.

PRESENTATION

When you are ready to write in Roman Rustic, here are some suggestions to make its use authentically early-medieval. The most noticeable thing is that space was not left between words, so the writing lookedalittle strangeallsqueezedtogether. Fortunately, the few people who could read were used to this and had little difficulty. They thought that spaces between words made the lines of lettering less pretty. Sometimes when it was thought important to be especially clear, they still refused to ruin the lettering with spaces but, instead, put dots between the words. The dots were not at the base of the letters where we put periods today, but halfway up the height of the letter. Even though the writing still looked·a·little·strange·all· squeezed·together, it was easier to comprehend.

Punctuation differed quite a bit from today's. Fifth-century scribes used : or ÷ as a period, • as a comma, •/ as a semicolon, ' as a quotation mark, and an **S** lying on its back as a question mark. They didn't start a paragraph by in-denting or leave space between paragraphs, but they marked the end of a paragraph with .·. and began the next paragraph by moving to the next line and starting with a capital letter. A capital letter was simply a regular letter made larger than the others. Sentences and proper nouns, though, were still begun without capitals.

Scribes used pages of many different sizes. Instead of writing long lines across the page as we normally do today, they preferred to divide their writing into two columns to the page. They also liked to fit their writing into what is called a square text block, a writing space as deep as it was wide. For margins around the edges, the Roman Rustic scribe would leave a medium amount of space at the top, and a deeper one at the bottom. For the sides he liked the same width on the left as on the right, choosing a size wider than the top margin but narrower than the bottom margin.

If you are writing something very short, set it in the middle of your page and keep in mind the scribe's ideas about top and bottom margins. Write it small and neatly,

and all the surrounding white space will draw the eye right to it. If you want to make it bold and exciting, begin with an enormous capital letter. Roman Rustic lettering was neat and orderly, and the capitals beginning each paragraph were usually the only decorative touch—the scribes made them by letting one or more of their strokes sweep into the margin.

Once you have developed a medieval hand and you know about medieval spacing, page design, and decoration, you can put it to use with your twentieth-century imagination. Use your Roman Rustic to write a P.S. all the way around the edges of a letter—it makes a pretty frame for your page. Address your envelope in Roman Rustic and you can be certain it will be the first one opened when the mail is delivered. Write short messages only one word wide, each word centered right below the other, and see what a striking design it makes.

Sending a secret message? The ancient Romans (and Greeks) were adept at such trickery. One technique was to shave the messenger's head, write the message on his scalp, and then keep him around until all his hair grew back. That way, nobody could see what was "on his mind," even if he were captured. This method works only if you have a lot of time.

A much easier and faster early Roman way for you to produce a secret message is to take a broomstick and mark a point below the end of the handle (say two feet). Take a long, thin piece of paper (about an inch wide) and hold one end of it at the two-foot point. Now wrap the paper around the broomstick, winding it toward the top of the handle and making sure that each winding slightly overlaps the previous winding, and that the paper is always snugly against the broomstick. When you reach the end, tear off and throw away the remaining paper. You can write a long message in straight lines almost two feet long right across the overlaps.

When you take the paper off the broomstick, it looks like a strip covered with pieces of words written at an odd angle, making no sense at all. The only other person who can read it is a friend who knows how thick a stick you wrapped the paper around, and how far along the stick you wrapped it.

Roman Rustic was a favorite style when great announcements were to be carved on gateposts and buildings and monuments. When you build something grand like a clubhouse, or small like a doghouse, declare, in Roman Rustic, whose it is, who built it, and when.

YOURS TRULY: KING ARTHUR

THE MAN

THERE was no medieval figure, real or mythical, greater than Arthur, king of Britain. The stories of his adventures, of the knights of the Round Table in the glorious hall in Camelot, are a source of legendary national pride to the English and Welsh and provided a standard of chivalry and glory throughout Europe in the Middle Ages. Medieval times passed, but the saga of Arthur and his kingdom never tired in the telling and fascinates people to this day.

How could there be a better story? There is the magic of the sword in the stone and the sorcerer Merlin, the intrigue of headstrong knights, the search for the Holy Grail, the love of a great queen, the breathtaking battles . . . all ending in an unforgettable death scene. No wonder Arthur was, to medieval people, one of the Nine Worthies, the nine most noble men ever to walk the earth.

The legend of Arthur is so captivating that perhaps it should not matter that only a small portion of it is true. For, while Arthur did exist, almost everything about his legend is what people of the Middle Ages wished to hear and to enjoy.

In the late fourth and early fifth centuries, Roman forces left England under pressure of problems in Europe and dangers to Rome itself. With the Romans gone, the peace and security of England quickly evaporated. Saxons from Germanic lands threatened the country from across the North Sea; Picts from the north ranged southward; Irish raiders crossed the Irish Sea to plunder the western shores. In Britain it was a dangerous time to be alive.

About 470, probably in the south, a boy named Arthur

was born. Almost nothing is known of Arthur and it may well be that he never learned to read or write. He did grow up learning to fight, however, and with the followers he attracted, he battled the Saxon invaders. He was a compelling leader—perhaps commanding a troop of cavalry—and he is mentioned by a Latin title meaning Duke of Battle. But his men were not knights, for knighthood had not yet been established; nor did he have castles but, rather, ditch-surrounded hill forts. Finally, he ruled no land and never became king.

But long before the tenth century, tales of his bravery against his enemies had already been recorded. In the twelfth century, when the medieval historian Geoffrey of Monmouth wrote the *History of the Kings of Britain,* he ended the book with the most exciting story of all, the history of Arthur, king of England and leader of a vast army of knights. When Henry II took the throne some years later, he supported the story because he wanted his countrymen to feel pride in having a noble and historic past. In France, which also loved the Arthur story, the poet Chrétien de Troyes gathered more legends together and, in his version, created the marvelous image of Camelot. And late in the fifteenth century, Sir Thomas Malory gathered all sorts of legends and wrote a long series of wonderful accounts which included the Round Table, Camelot, love affairs, and chivalry.

Each storyteller had enhanced the legend by adding to it the elements that were considered most glorious and exciting in his own time. Everyone wanted to believe that Arthur and his kingdom had existed and that good would always triumph. It was comforting, when danger threatened, to feel that an Arthur might rise up to restore peace and justice.

Plate 10 shows a portrait of Arthur that was produced in the late thirteenth or early fourteenth century for a chronicle, or history, which included the great rulers of Britain. As was the custom, Arthur is shown dressed and armed in a manner appropriate to the period, with a painting of the Virgin and Child on his shield. The scribe/illuminator showed how great and powerful Arthur was by placing him standing on thirty crowns, each representing a kingdom over which the triumphant king was supposed to have ruled.

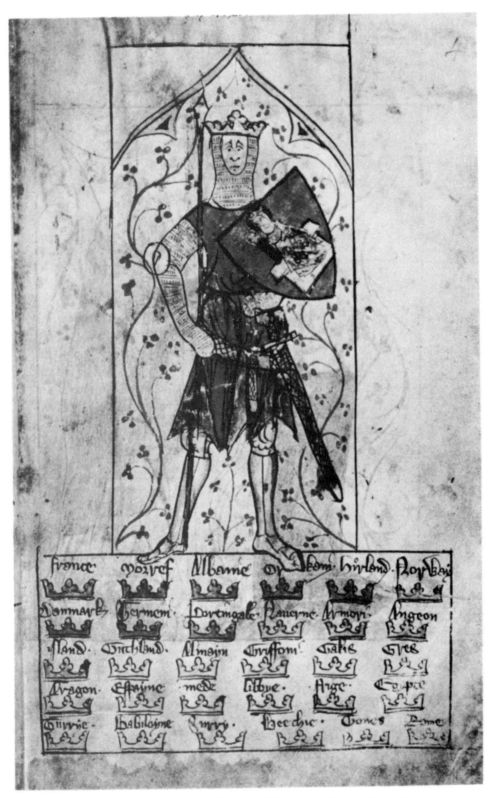

Plate 10. London, The British Library, MS Royal 20. A. II, folio 4 recto.

Had the real Arthur been taught to write, his teacher would have been a monk who would have taught the lad the easiest and quickest script—Roman Cursive. But for fine writing he might have learned the graceful script of Rome, Uncial, the script of fine books which, despite the dangers of the day, were continuing to reach Britain from Rome.

the script

As captive European populations began rising up against Roman rule and people began losing faith in their pagan gods, the Christian faithful grew in number and influence. Still, the Church itself had no official language or script. The few Christian books in Rome were written in the Greek language and alphabet; those in the provinces were written in the Latin language and script. Fortunately, something had taken place in Egypt in the second century that helped solve this dilemma. Christians there knew both the Latin and Greek languages and scripts and, gradually, the two had become somewhat mixed. Scribes discovered that the gentle curves of the Greek letters were easier to write than the rather stiff shapes of the Roman letters. Here are some of the premedieval Greek letter shapes (the one in the middle is not a **W**, but the Greek letter "omega").

μεωθα

When the scribes took the shapes of some of their Roman letters

and rounded them,

ROMAN

the result was a pleasing letter form that could be penned more quickly.

In the first half of the fourth century, Christianity became the official religion of the Roman Empire and Latin was made its official language, with the mixed script from the provinces, which we call Uncial, becoming the official script. Christians in Rome, used to Greek books, could read it, while people elsewhere, used to Latin books, could also read it. Because it could be written fairly rapidly, the books could be supplied quickly, and Christian leaders were pleased by the important look of this new, bold style of writing.

By Arthur's time, Uncial had become a rounded, rapidly written formal script. All the letters were large capitals (called majuscules). Some letters, despite being capitals, had the shape of what we now call lowercase letters (minuscules) and, in fact, were the distant ancestors of our lowercase alphabet. In the sixth century, Uncial began to change. Scribes adopted the habit of holding their nibs almost horizontally instead of at an angle. This made the letters heavier and more dramatic:

ROMAN

But it also made them slower to write and, as time went on, scribes began using simpler scripts for most of their work, saving Uncial for their important writing. Because appearance counted more than speed in important documents, they started adding time-consuming twists to the Uncial letter shapes.

ROMAN LETTERS

During the sixth century so much twisting and embellishment were added that it really became a different script, and the earlier Uncial began to disappear.

Early Uncial is a fine script to learn because it is graceful, easily written, known everywhere, and has a grand history. Perhaps the finest example was the work of an Italian scribe in about the year A.D. 450. By that time Uncial was well established as the official script of the Christian Church and known throughout the Western world. The lettering shown in Plate 11 was done carefully, yet it flowed along quickly, so quickly that some of the strokes were begun before the nib touched the writing surface. That is why, most noticeably in the **E**, the top is not connected to the side, and we can see that the top and side were indeed two strokes rather than a single one. Similarly, the top of the **S**, and the loop of the **R** and **B**, for instance, seem to be unconnected to the rest of the letter. If a familiar word could be abbreviated, it was, saving time and space. To show that a word was an abbreviation, the scribe drew a line above it (today we place a period after it). The lettering in Plate 11 is shown in the size it was written, so only a portion of the page can be shown here.

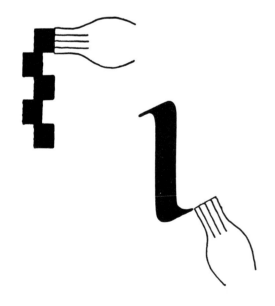

Note that the ductus of the Early Uncial is the same as in Roman Rustic, and that the scribe chose a proportion of about five nib widths for the height of his basic letter shapes.

When he penned his letters, the nib was usually at an angle of about 30 degrees, not as steep as the angle used in Roman Rustic. In the letter **I** at left, the stroke begins and follows through the nib at a constant 30 degrees. Such a stroke, regardless of the nib angle, is called a minim stroke. It is the simplest stroke of all, starting at the height most letters begin and finishing at a level where most

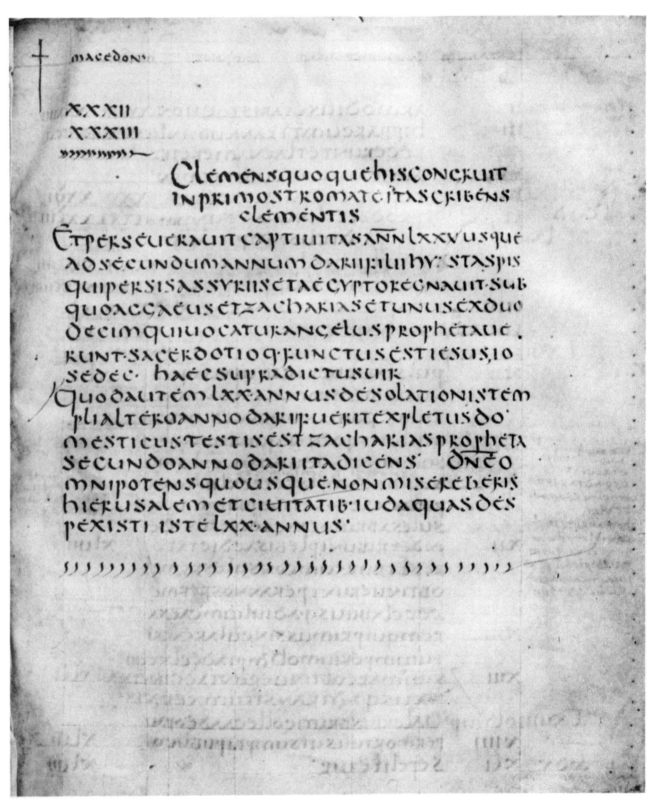

Plate 11. Oxford, Bodleian Library, MS Auct. T. 2. 26, folio 82 recto.

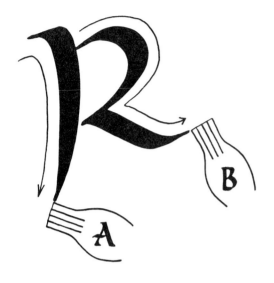

letters end. (**T**, for instance, contains one stroke, and **H** has two.)

But the scribe added some calligraphic touches. When he had a vertical stroke that began above the minim or, as in Uncial **R**, went below the minim, he (A) began with the nib at about 30 degrees, but near the bottom he began twisting it to a steeper angle, so that the descender (the part of the stroke going below the minim) became thinner. Instead of being heavy, and making the letter look lopsided, it tapered gracefully. He did this with all descenders. For the second stroke (B), he began at 30 degrees and didn't alter the angle. Because the letters were penned rapidly and seemed to flow along, many of the vertical strokes are slightly arced, not vertical. I have exaggerated this arc in the illustration, but it is there in many of the scribe's letters if you look closely, and if you add a slight arc your Uncial, too, will be more graceful.

how to do it

Begin by penning a stack five nib widths high. If you are using the same grid paper and nib size as on pages 60 and 61, your minim stroke will be four-eighths of an inch high. Keep your nib at about 30 degrees for all lettering except for the special situations mentioned above. Notice that in this alphabet there are short descenders (on **G**, **N**, and **R**), long descenders (on **F**, **P**, **Q**, and, sometimes, **X**), and short ascenders (parts of the letter that rise above the minim, as on **D**, **H**, **K**, **L**, and, sometimes, **Y**). And remember this: don't dot your **I**'s, but do dot your **Y**'s, even though this scribe seemed to forget. Medieval scribes were concerned that **Y** might be mistaken for a similar foreign symbol, so they put a dot above it to make clear that it was **Y**.

Pages 60 and 61 show the ductus of each letter of the Uncial alphabet, plus those letters which were unknown then. This lettering is based on the scribe's hand, but added to it are a few touches admired in other hands. Once again, let my hand be your basic guide, but let the medieval scribe's be your example for fine shape and

spacing. Not many students have a medieval teacher, and in this you have an opportunity to learn from the best, so keep turning back and comparing your work with his.

PRESENTATION

As in Roman Rustic, space was not left between words but, in the days of Uncial, neither were dots added to make reading easier. You ought to leave enough space to keep the reader from being confused, but not so much space that he or she thinks words were separated as they are today. For punctuation and paragraphing, since this Uncial is only a little more modern than Roman Rustic, the same general rules applied as for the earlier script.

When scribes who wrote Uncial needed a capital, they usually just enlarged an Uncial letter. This happened only at the beginning of paragraphs, not at the beginning of sentences or for proper nouns. When the scribe wished to be decorative, he exaggerated the Uncial letter, lengthening some of the sweeping lines and positioning it so that it extended partially into the margin. If he wanted his writing to appear more important, he needed an important-looking capital. Since we tend to believe that things that are old are important, the scribe saw old Roman Rustic as being very significant. He often started his paragraph—or even spelled out the title of what he was writing—in Roman Rustic.

Scribes with imagination liked to make their most important capital letters represent the life they saw around them. Capital **I** might be a simple drawing of a long, thin fish standing on its tail. Capital **T** might be that same fish holding a similar fish in its mouth, the second fish forming the top of the **T**. If you like drawing birds, sketch one with a long beak pointing to the right, a long leg to stand on, and another long leg kicking out to the right, to create a capital **F**. A long snake biting its own tail forms a capital **O**. Two men shaking hands form a capital **H**, and so on. These "living" capitals were used more frequently with the script

Remember to

1. Arc the vertical strokes slightly.

2. Twist the nib slightly as the stroke ends, to taper the end of the descender.

TWO OTHER A'S:

and

The end of the 2nd stroke and all of the 3rd stroke are penned with the left corner of the nib.

Yes, this stroke takes practice to do so that it is round and graceful. Everyone finds it the most difficult stroke. Keep trying.

Use only the left corner of the nib for the up-ward swing here.

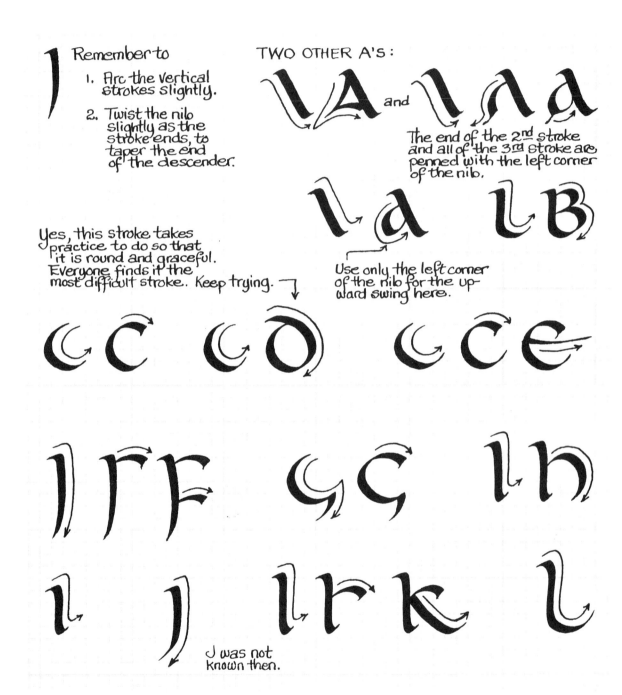

J was not known then.

Uncial

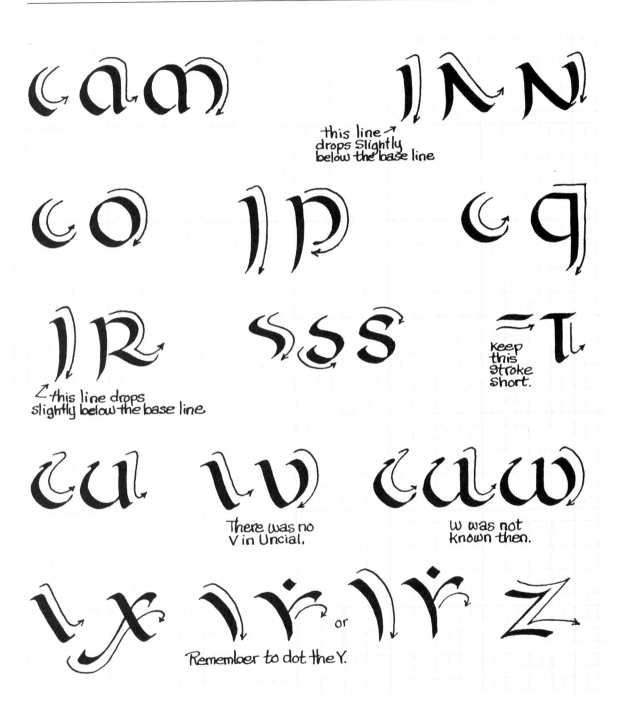

this line →
drops slightly
below the base line

⊾this line drops
slightly below the base line

Keep
this
stroke
short.

There was no
V in Uncial.

W was not
known then.

Remember to dot the Y.

61

that followed Uncial, but they give a feeling of the imaginative urge that inspired the work of the creative scribe in the early Middle Ages.

Since Uncial was the first official script of the Christian Church, it is the one you might choose to use when you pen posters and notices for church activities. For this reason, it is the most appropriate script for Christmas cards.

Uncial not only looks old but, because we like curved letters, it can also seem gracefully modern. If you wish it to look authentically old, design the page as you would a Roman Rustic one. The rules for columns, margins, and text-block shape had not changed much by the time Uncial came into favor.

If you have to do a report on Arthur in English or history class, Uncial is the appropriate script to use, but be ready to defend your choice. So famous was he in the late Middle Ages that he is thought of as a warrior king of that time and most people think the late-medieval scripts were those of his day.

best wishes, charlemagne

the'man

NEVER before had a script been named for a man—but then there had never been a man like Charlemagne. As a historic figure he towers over everyone else in his time, for the emperor of the West looked the way people thought a king should. He stood more than six feet tall, was powerfully built, with keen eyes and flowing white hair. He was the hero of battles, the winner of wars, the defender of the Christian faith, and a man who dearly loved education.

Carolus, for that was his Roman name, was born about 745. The son of a king, he was educated more in castle manners and the art of riding and fighting than in reading and writing. Even when he became the ruler of most of Europe in the year 800, his spelling was inadequate and his writing not much better. That didn't matter to the people in his court, who called him Carolus Magnus, or Charles the Great, nor did it matter to his subjects who, in their language of the day, called him Charlemagne. But it mattered to him. What he did about it well before 800 started the great revolution in the history of medieval scripts. It also helped create both the scripts we write and the printing we read today.

Charlemagne was well beyond childhood when he realized that there was more to life than hunting and fighting. Discovering that the world was full of great knowledge and wisdom for those who could read, he gathered scholars to his court and worked on improving his education. As he became more familiar with the state of learning, he was concerned to find that so many different

63

ways of writing were flourishing throughout his empire.

The early Uncial of Arthur's time had become so calligraphic that it was difficult to write quickly. For most of their work, scribes turned to a familiar old script that was easier to use, called Roman Half-Uncial. In this script, the ancestors of our lowercase letters can really be seen:

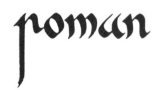

But the old habit of trying to make things finer was still at work. In Arthur's lifetime, Irish scribes studied the Roman Half-Uncial and then applied their creativity to it. In the sixth century they had begun producing a beautiful script known as Insular Majuscule which required careful penmanship and considerable time:

At the same time, for the bulk of their work, they created a handier script called Insular Minuscule:

They soon taught both of these scripts to English scribes and then traveled across Europe teaching others. In the meantime, scribes in different areas of Europe were developing their own styles. A famous one, popular for less than two hundred years, was Luxeuil Minuscule, named for the French monastery in whose scriptorium it originated:

Imagine a map showing scriptoria all over Britain and Europe, each employing the particular script of its own area. To this add the old Roman Cursive still in use universally, the new, independent scripts growing in each separate region, and perhaps half a dozen more scripts we haven't considered. If one thing is obvious, it is that the spread of writing was in great confusion. And because Charlemagne ruled most of the area of our map, most of this confusion covered his empire.

The answer seemed to be a common script, one that was easy to write and easy to read. We don't know whose idea this was—perhaps Charlemagne's, or perhaps it was suggested by Alcuin, an English monk who was one of the greatest scholars at Charlemagne's court. He and Charlemagne, pleased with a simple script used by the scribes of several nearby monasteries, decided that should be the form taught to the court scribes. Alcuin was made responsible for this task, and, in the process, some rules about the script were formed and some changes made. In 789, orders were issued that this was to be the official script throughout Charlemagne's vast empire.

the script

One of the most helpful new rules dictated that every word should be separate from its neighbors. Each letter was to be simple, rounded, and clear, its ascenders rising a minim stroke's height above the minim, and its descenders falling the depth of a minim stroke below the minim. It was a script referred to by several names in Charlemagne's time, but centuries later it was given his Roman name (Carolus) and called Carolingian Minuscule.

Carolingian Minuscule began as a simple, useful script. As time went on, its popularity grew and it became famous throughout Europe. Scribes in England knew and used it for writing in Latin but not for writing in their native language. Only when the Normans from France, who wrote in Carolingian Minuscule, invaded England in 1066 and insisted it be used did it finally become the major script of England. The last to acquire it, the English did

what others had done before them—they added their own variations to it. And so the English version became most dramatic, as you can see from Plate 12, which shows a page of formal, very calligraphic Carolingian Minuscule penned by an English scribe about 1125. Notice the exaggerated way this scribe penned large capital letters to show the beginning of a paragraph. On the same line as the capital **A** is a very early use of a new letter, **W**. The lettering in this illustration is in the same size as the scribe penned it, so his page had to be trimmed to fit here.

In the last two centuries of the Middle Ages, when other, far more complicated styles of lettering had come into fashion, another revolution in lettering arose. Italian scribes wished for a simpler, less fussy way to write, and, knowing that their country had been responsible for laying the foundations of Western lettering, they wanted to return to the ancient clear, clean designs. They remembered that the knowledge-loving scribes of Charlemagne's day had copied many ancient Roman manuscripts, so they looked at Carolingian lettering and, it is believed, took it to be the script of ancient Rome. With the Carolingian Minuscule to guide them, they adapted the late-medieval Italian scripts and, as the Middle Ages ended and the Renaissance began, these became known as the Humanist Bookhands. One of them, sloped so it could be written more quickly (unlike any of the formal medieval scripts except for occasional variations), became the Italic hand now so famous. These scripts are the ancestors of the styles in which we write and the typefaces we read today.

how to do it

Carolingian Minuscule was used in so many different scriptoria and over such a long period that many versions of it came into existence. Depending on the hand you look at, it may have been written with the nib held at as little as

Plate 12, right. Oxford, Bodleian Library, MS Bodley 717, folio 5 recto.

egrotacionem corporis accedat egritudo animi: dupplicat infirmitas.
Int ipsos quoq; sensus & omnia membra corporis. principale locu obtine
caput. in quo uisus & odorat. auditus & gustus est. Cum q caput dolu
erit. omnia membra debilia sunt. Et p metaforam doce. quod a prin
cipibus usq; ad extrema plebem. a doctoribus usq; ad integru uulgus
in nullo sit sanitas. sed omnis impietati pari ordine consentiant.
A planta pedis usq; ad uerticem. non est in eo sanitas. Vln̄ & liuor & plaga tumens.
seruat coeptam translacionem. A pedibus usq; ad uerticem idest ab imo
usq; ad summu. ab extremis usq; ad primos toto confossi sunt corpore.
Vulnus inquit & liuor & plaga tumens. Aut eni uerberibus liuent
corpora. aut plagis tument. aut hiant uulneribus. Querimus
cui hec tempori coaptanda sint. Post babyloniam captiuitatem
sub zorobabel & esdra ac neemia isr̄l reuersus est in iudeam. & an
tiquum recepit statum. Sub diuersis quoq; principibus ac regibus
templum augustius fabricatum est: in tantum ut etia externa
rum gentium. lacedemoniorum & atheniensium. ac romanorum
mererentur amicitias. Ergo hoc quod dicit non est in eo sanitas:
ad extrema refert captiuitate quando post titum & uespasianu
& ultima euersione iher̄l'm sub helio adriano usq; ad presens tep̄s
nullum remedium est. impletur q; q̄d scriptum est. omnis declina
uerunt simul inutiles facti sunt: non est qui faciat bonu. non est
usq; ad unum. Quoq; infertur. non est in eo sanitas: uel in ppl̄o
intellige. uel in corpore. uel in capite. Non est circu ligata. nec
curata medicamine. neq; fota oleo. Pro quo septuaginta transtu
lerunt. Non est malagma imponere. neq; oleum. neq; alligaturas.
Vsq; hodie uulnus & liuor: & plaga tumens popli isr̄l non est circu
ligata fasciolis. nec curata medicamine. quod aquila μοτωσιν in
terpretatus est. lintheola uidelicet que ad exsiccandam saniem
& purulentias extrahendas intruuntur uulneribus. Neq; fota oleo.
ut eorum duricia lacrimis poenitentie molliretur. Pro fasciolis q̄bus
isr̄belis nequaqua circum ligata sunt uulnera: septuaginta
malagma transtulerunt. lacet q confossus & contrucidatus isr̄l:
quia inter se medicum qui ad curandam uenerat domu isr̄l.
Vnde & in iheremia tropicos supp̄ sona babylonis locuit angeli
Curauimus babilonem & non est sanata. urbem uidelicet con
fusionis atq; uitiorum. Et in euangelio legim̄ discendente de iher̄l'm
in ihericho a latronibus uulneratu curatumq; a samaritano. & post
austeritate uini. infusam uulneribz et olei mollitudine. A beo ergo

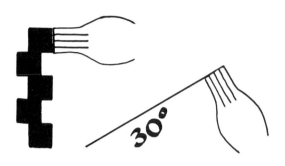

10 degrees to as much as 45 degrees, and the letter height varied from three to five nib widths. The thing to keep in mind is that the closer you wish your script to look like that of Charlemagne's court, the more you tip the nib and the rounder you make your curves.

The excellent example provided in Plate 12, produced late in the era, was penned with nib at about 30 degrees and with a five-nib-width letter height.

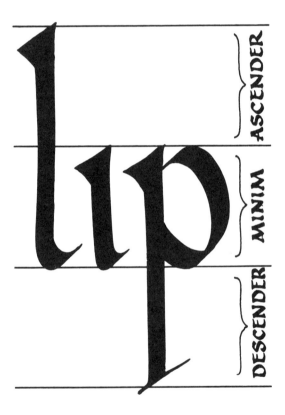

Remember Alcuin's rule about ascender and descender lengths: they should be equal in length to the minim stroke.

There were several versions of ascenders. The first (1) was the oldest, originating with the early Roman Cursive

habit of starting an ascender with a big, casual upward swing. The result of overlapping the upward and then downward swing created a bat-shaped ascender that was popular in early Carolingian Minuscule. The second (2) is the early split ascender, a little more calligraphic.

Even more calligraphic was version (3), favored by English scribes after the Normans had persuaded them to use Carolingian Minuscule for writing in their native language. The script also had a few letters that were noticeably tied together:

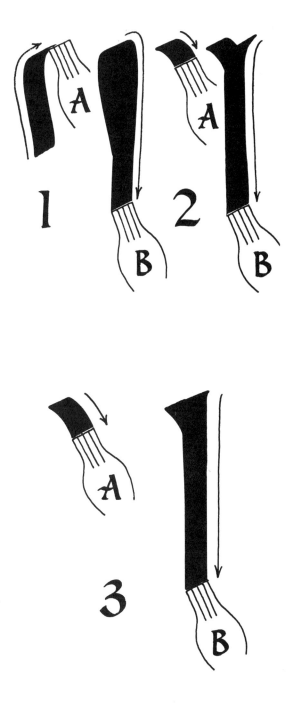

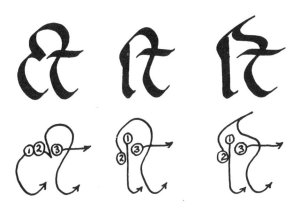

Letters tied together are known as ligatures. In Carolingian Minuscule the **ct** ligature (above left) and **st** ligature (above middle) were most common. Some scribes also used an **rt** ligature (above right). Few people today recognize the long **s** (even though it was in use in America in the early 1800s), so you might keep the flavor of the script by substituting the other **s** shape:

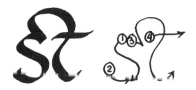

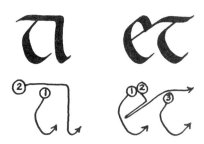

This shape was used in a popular ligature at the end of the Middle Ages (so popular that occasionally a sweeping line connected the **s** to the following **t** even though several letters stood between them). But there is no proper way to modernize the **rt** ligature. The script also included some letter placements that were not really ligatures, but a touching together of two letters because the last stroke of the first ended where the start of the second began. If the scribe didn't bother to lift his nib (and this was often the case), the letter **t** would link with **i** and the letter **e** with **t.** As you learn to write Carolingian Minuscule you will discover many opportunities where an **e** or **t** can "tie" to the next letter. Do it if you think it would add some flavor to the appearance of what you are writing. But don't get carried away—remember the script was designed in the first place to be read without trouble.

Two final things to consider: a letter that wasn't all there, and a case of too much letter.

The letter that wasn't all there was the **r** whenever it followed **o.** Carolingian scribes felt that the right-hand curve of **o** could at the same time serve as the minim stroke of **r.** So they created the half-**r** to save time and space. In exactly the opposite way, some scribes took more time than necessary, penning too much of a **d** in order to make it look graceful. These scribes first penned a complete **o** and then overlapped it with the upright stroke.

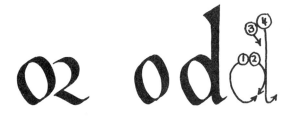

On pages 72 and 73 you will find the ductus for the Carolingian Minuscule alphabet, plus the letters added later that we use today. This lettering is based on the excellent scribe's hand, with a few touches admired in other scribes' hands. Remember to let my hand be your basic guide, but let the English scribe be your real teacher. Look to him to see exactly how a letter is best shaped, how space is apportioned, and so forth. Keep turning back to Plate 12 to compare your work with his.

presentation

In Carolingian Minuscule the comma, question mark, and quotation marks appeared just as they do today. The period, though, was still a dot at mid-minim height, and at

the end of a paragraph or chapter it often appeared like a modern colon (:) or a colon followed by a dash (:–). Paragraphs were indicated in the old fashion, by starting the first sentence with a capital at the far left of the line of writing. Remember that this script introduced the practice of separating words.

Charlemagne's passion for knowledge and great respect for the books and writings of the past kept Carolingian scribes busy copying early writings to prevent their being lost or forgotten. The respect not only for what had been written, but also for the way it had been written, made a difference in the way Carolingian scribes penned their capitals. For a simple capital beginning a sentence, a Roman Rustic letter was used. An important capital, beginning a paragraph or chapter, called for a Roman Square Capital letter. Titles deserved Roman Square Capital letters with exaggerated sweeps and larger-than-normal serifs to make them look fancier.

In Charlemagne's day and after, the popularity of square text-block lessened. Scribes and readers admired books in all shapes and sizes and preferred small books if they contained something they might carry about with them, like their own church service books or personal notebooks.

If, on the other hand, it was an important presentation, the bigger the pages the better, because the book might be placed in a position of honor in the monastery or even on the altar of the church. But the general rules about how big a text block to use on the size page chosen, and how large to make the margins, were about the same as those followed by the Roman Rustic scribes.

Because Carolingian Minuscule began in the eighth century and was still in use in the twelfth century, it is a script you can use in any project or study that involves events that occurred in those five centuries. And because it is the script the Italian scribes adapted in the Renaissance, it is a graceful script that can look quite up-to-date if you avoid use of the old long **s**, long **r**, half **r**, or confusing ligatures.

For projects that are powerfully medieval, you might use your script to produce strong magic. Here are two spells you can practice writing—first a good one, then a bad one.

Take a small slip of parchment or, second best, a bit of leather. Pen the word "abracadabra," turning the leather

Ascenders and descenders
need not all be identical length.

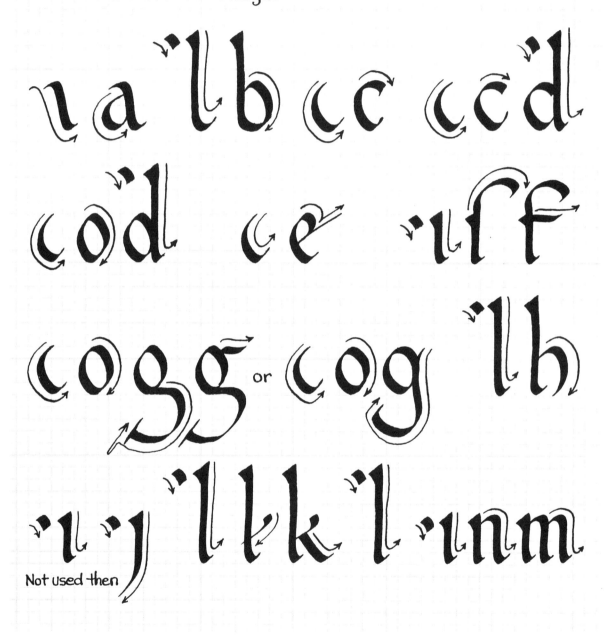

Carolingian Minuscule

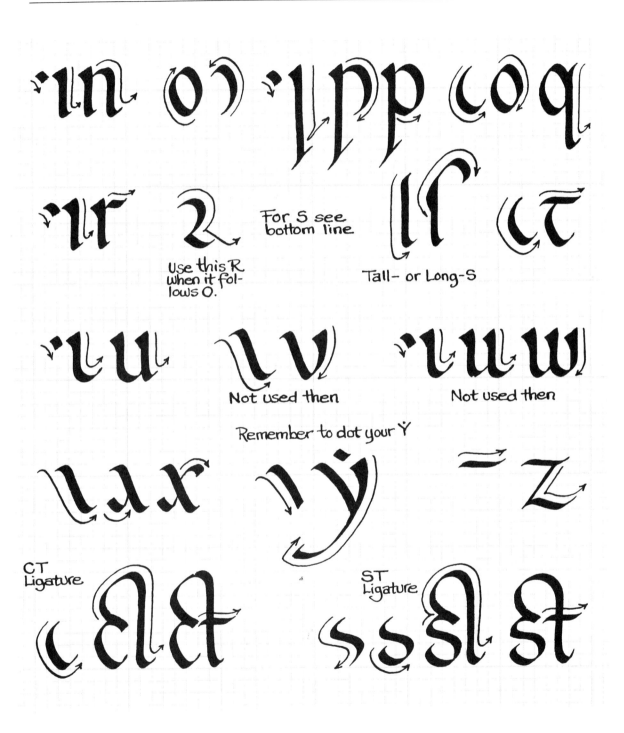

For S see bottom line

Use this R when it follows O.

Tall- or Long-S

Not used then

Not used then

Remember to dot your Y

CT Ligature

ST Ligature

as you do, so that instead of being all on one line the word forms the outline of a triangle. Poke a hole in one end of the slip, put a string through it, and wear it around your neck. In the Middle Ages, people believed that such a potent word in such a mystical shape would make them safe from all manner of illness.

Bad magic, they knew, was dangerous stuff. But to the scribes of Charlemagne's time, people who stole books, ripped them, or scribbled in them deserved all the evil they got. A scribe who had just labored long and hard copying a thick and difficult-to-read manuscript would be horrified at the thought of someone's mistreating it, so it was not uncommon for the scribe to pen, in the beginning of his manuscript, a curse on whoever might steal or harm the book.

If your schoolbooks have a habit of disappearing, or if friends borrow your favorite novels and fail to return them, put this authentic medieval curse in the inside front cover of the next copy you're concerned about. By all means write it in the original Latin:

Liber . . . quem si quis abstulerit, morte moriatur; in sartagine coquatur; caducus morbus instet eum et febres; et rotatur, et suspendatur. Amen.

Translated, it reads:

If anyone takes away (or steals) this book, let him die the death; let him be fried in a pan; let the falling sickness and fever seize him; let him be broken on the wheel, and hanged. Amen.

With kindest regards, Robin Hood

The Man

WHEN the Magna Carta, the great English Bill of Rights, was forced upon King John by the nobility early in the thirteenth century, laws and regulations increased justice for the higher ranks of English society but changed little at the lowest levels among the masses of ordinary citizens. Poverty was widespread, opportunities and protective laws were minimal, and the bulk of the citizenry were harassed by the aristocracy and the courts, soldiery, and sheriffs who represented them.

The division between rich and poor was so wide that neither truly understood the other, and the rising passion on the part of the poor for rights and respect went almost unnoticed.

One sign of discontent was the growing popularity of certain stories spreading by word of mouth, stories that involved the oppressive rule of King John, the lawlessness of a particular sheriff, and an "ordinary" man, like themselves, who was bold enough to steal the king's deer, thwart the sheriff, take from the rich to help the poor, and aid in restoring to the English throne the much loved Richard Lion-Heart.

That ordinary man was Robin Hood, and the life he led in and about Sherwood Forest and Nottingham was, to the lower classes in their growing unrest, a vicarious expression of their discontent. Robin Hood, defender of the poor and foe of the unjust powers in the land, became ever more popular as stories of his exploits spread.

The earliest known written account of Robin's adventures occurred in 1377, and as more were written and

enlarged upon, other names gained fame along with Robin's—Little John, Allan-a-Dale, Friar Tuck, Maid Marian, and others. So beloved was Robin Hood and so satisfyingly thrilling were the stories about him that, even though the plight of English citizenry improved, the stories remained irresistible. They are still among the favorite traditional tales today, in a time when the way of life that created them no longer exists.

John and Richard, of course, were flesh and blood. Sherwood Forest and Nottingham stood then where they stand now. But Robin Hood was naught but wishful hope. Had he actually lived, it is unlikely that he would have known how to write. But the scripts that John knew and that the sheriff used in the early thirteenth century are famous. And the formal script with which the orders for the capture of Robin Hood would have been written represents the finest calligraphy of his day.

The Script

The script of Charlemagne's court late in the eighth century started a major change in the way people throughout Europe and England wrote; by the early twelfth century, it had been changed by thousands of scribes from a simple, quick script to a dramatic style of lettering. Then the different values of a new era—the Gothic period—began taking effect; education was becoming a reality for those of the upper and middle classes who wished to pursue it. And, as we have seen before, the new and different requirements of society brought about a change in the style of writing.

With the demand for books, scribes had to produce their writing more quickly, while at the same time using as little expensive parchment as possible. They discovered that if they squeezed the letters by making sharper turns in their curves, more speed could be obtained and more letters would fit on a line. This early Gothic experimentation began at the start of the eleventh century and continued until the end of the twelfth century. Along the way, Early Gothic looked somewhat like the following.

roman

The squeezing and sharper turns, done out of necessity, looked so appealing that scribes began squeezing more, turning sharper, and delighting in the artistry of the result. As the thirteenth century began, they had created a Gothic Textura:

roman

Gothic Textura scripts are given that name for two reasons: they are from the Gothic period of the Middle Ages, and the way the letters were shaped and placed together created a pattern that could be described as a woven design. The Latin word for woven is textura.

The new approach to letter placement was one of the most significant attributes of the Gothic Textura scripts. No longer was each letter best left standing alone; now the emphasis was on words formed by placing letters together, their relationship forming a design. When an expert scribe penned Gothic Textura, the words looked like separate designs even before one noticed what letters were in them—so pretty that a page of Gothic Textura turned upside down still represented a collection of attractive designs.

One way to make a pleasing pattern is to repeat a shape constantly. Scribes discovered that what makes each letter of the alphabet recognizable is usually the top half of the letter. (You can see this by turning back to the title of this chapter and covering the bottom half of the lettering.) When the scribes realized this, it meant they could make the bottom half of most letters look alike. And the repetition of this single shape made a pattern.

There were actually two kinds of Gothic Textura scripts, the main difference between the two simply being that in one, at the bottom of most strokes, the line was turned at an

angle to make a fancy foot. This script is known today as Gothic Textura Quadrata. In the other script, most lines ended flat. No fancy foot. That script is known as Gothic Textura Prescisus vel sine Pedibus, the title a writing master, around the year 1400, bestowed on it when he penned his wall poster offering to teach it. Those last four words mean "exactly and absolutely without feet."

The two types of Gothic Textura script are sometimes called Black Letter because the strokes are so close together that they darken the page. Another popular name is Old English, because it is old and English, but people serious about the history of scripts prefer names that offer specific information.

Paleographers are still studying the history of Gothic Textura. Some believe that Gothic Textura Prescisus vel sine Pedibus is the older, created by scribes in England, and that it was then taught to scribes in France who turned it into Gothic Textura Quadrata. Scribes in Britain and Europe soon were familiar with both versions. The footless script, though, would thus be the more appropriate to the days of Robin Hood and would be the script Friar Tuck would have employed in his monastery scriptorium. It is the better script to learn because it looks quite difficult even though it isn't, it is easier to read, and fewer people today have ever seen it. As you learn how to do it, you will also see what changes to make so that you can learn Gothic Textura Quadrata as well.

The scribe to learn from is the calligrapher who wrote in the part of England known as East Anglia. Plate 13 shows a page from England's famous Ormesby Psalter, penned in about 1300. This scribe's name is not known, but his work is famous. Because the photo shows the lettering in the same size as it was written, it was not possible to include the entire page, surrounded by creative vines and creatures. Notice that, whenever he could, the scribe ended his minim strokes flat. That is the major difference between this script and its better known sister.

Plate 13, right. Oxford, Bodleian Library, MS Douce 366, folio 131 recto.

tuis famulis mīsēdiam atqꝫ iudiciū
clementer infinuas: concede nobis qꝫ.
fideliter te diligere. rectamꝙꝫ viam tuā
ingredi. ⁊ auanitate erectabilis suꝑbi
e declinare. per .

omine eraudi oratio
nem meam: ⁊ clamoz
meus ad te veniat.

on auertas faciem
tuam a me: in quacumꝙꝫ die tribuloz
inclina ad me aurem tuam.

nquacumꝙꝫ die invocauero te: velo
citer eraudi me.

ura defecerunt sicut fumus dies mei:
⁊ ossa mea sicut cremium aruerunt.
ercussus sum ut fenū ⁊ aruit coz meū:
qa oblitus sum comedere panem meū.

voce gemitus mei: adhesit os meum

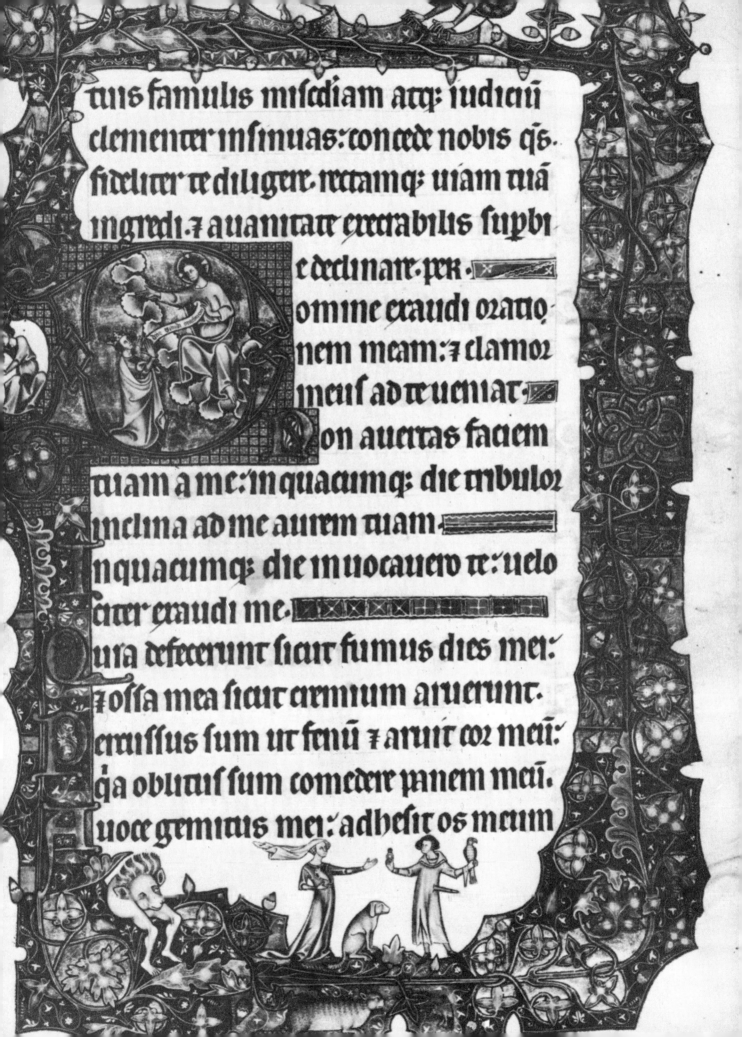

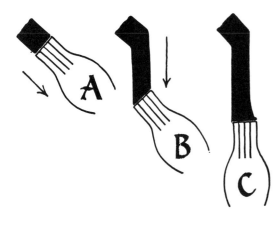

How to do it

Gothic Textura scripts were very calligraphic forms in which it was more important to be careful and exact than to be quick. Each time the nib changed direction it stopped for an instant so that a crisp corner was shaped rather than a sloppy angle or curve. Sometimes the scribe not only stopped but lifted the nib before lowering it to go on in the next direction, making one stroke into two or more shorter ones.

Held at 45 degrees, the nib formed a minim stroke that began with a line (A) as long as it was wide. You don't have to measure it; you know it is the right length when the stroke looks like a diamond. Then the scribe made the vertical stroke (B). In Gothic Textura Prescisus vel sine Pedibus, he ended it with the familiar twist (C) so that it would finish flat. Thus, the letter **M** looks like this:

If the scribe wanted to pen a fancier version, he began with the same diamond shape and then for stroke (B) started the vertical line in the center of the diamond instead of along its side. He finished (C) with a twist to flatten the bottom, and his **M** was still vel sine Pedibus, but was also a more artful design.

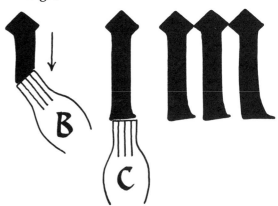

The scribe penning Gothic Textura Quadrata had the same choices once he had penned the beginning diamond. He could do stroke (B) in the usual way and then (C) repeat that diamond to give his stroke an angled foot, or he could lift the nib after stroke (B) and in stroke (C) place that diamond shape in the middle of the vertical line. This made the most complicated design, as the **M** indicates.

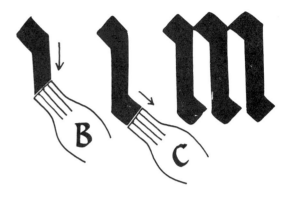

Remember that the secret of a calligraphic Gothic script was to make the work into a pattern. Look back at all four M's and you will see the following constants: the scribe kept all his tops as much alike as possible and in a perfect row, all his bottoms as alike as possible and in a perfect row, and between each vertical stroke he left a space just as wide as the stroke itself. Even when a letter had to have a different bottom, he tried to make those strokes look as much as possible like the repeating strokes.

For the ascenders in **b, h, k,** and **l,** the scribe had several choices. A favorite was the "split" made by (A) penning a curve with the nib held at 45 degrees but tilted so that only the left half touched the surface. Then the vertical stroke (B) covered the end of that stroke. Another was the flat top. It can be done (C) with the familiar twist stroke. I think some scribes used it this quick and simple way. Most others did it in two quick strokes that, together, accomplished the same thing.

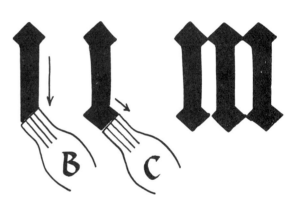

The scribe of the Ormesby Psalter made his letters about five nib widths tall (while others made theirs three, four, five, or even six, and some elegant documents' first words were done at twelve or more). Begin by making the usual stack of nib widths. If you are using the same nib and grid on pages 82 and 83, your minim stroke will be four-eighths of an inch high.

On the following pages is the ductus of each letter of the Gothic Textura Prescisus vel sine Pedibus alphabet, based on the Ormesby Psalter scribe's hand but added to with a few touches admired in other late-medieval Gothic hands. While these two pages will help you, remember that the Ormesby Psalter scribe is a much more appropriate teacher. Keep turning back to compare your work with his; let him show you about space between words and between lines, how high to make ascenders, how low to make descenders, and other matters of proportion.

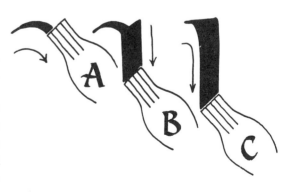

81

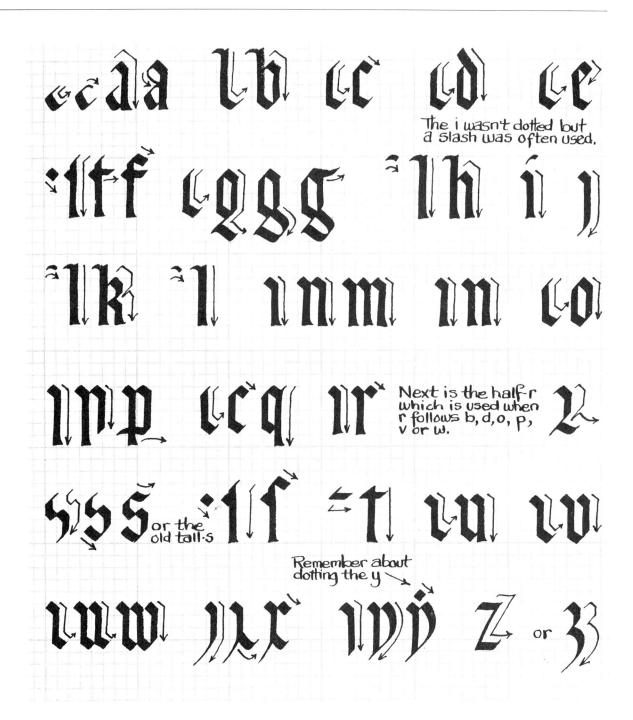

The i wasn't dotted but a slash was often used.

Next is the half-r which is used when r follows b, d, o, p, v or w.

or the old tall-s

Remember about dotting the y

Gothic Textura Prescisus vel sine Pedibus

82

Here is the same script with more un-
usual shapes - based on a 15th centu-
ry German style.

a b i d e f g h i j k l m n

n p q r i s ſ t u v w x y z

And now with overlaps for diamond
patterns & with split
ascenders

1. 2. 3.

a b c d e f g h i j k l m n

o p q r i s ſ t u v w x y z

83

Presentation

Punctuation in Gothic times was much as it is today. The only change you might consider is to place your commas and periods at midminim height to make the punctuation appear more antique. And remember to give your question mark angles instead of curves.

Capitals in this script marked paragraphs, sentences, and, finally, even proper nouns. But a new concept had occurred with the coming of Gothic Textura. For the first time, capitals were not simply larger copies of the standard letters or borrowed letters from earlier alphabets. Instead, a separate set of letters was created specifically as capitals. There are many variations in Gothic capitals—it is almost as though each scribe or scriptorium added an individual touch. On the opposite page is a rendition of one set of capitals based on those used by an English scribe late in the 1300s. A few notes are added to it to make some of the strokes clearer.

Gothic Textura Prescisus vel sine Pedibus is a grand script to use for anything old because most people who see it and don't know the history of lettering think that it is the famous script of the entire Middle Ages. That is why you can use it for Christmas cards and reports and projects on King Arthur or Robin Hood.

While Gothic Textura Prescisus vel sine Pedibus died with the end of the medieval era, Gothic Textura Quadrata lived on. After many years it was popular only in Germanic lands and was used there right into World War II. So there are many uses you can put it to in projects relating to the first half of the twentieth century.

Because it is thought to be the most important and ornate "old" script, it is popular for formal announcements (weddings, for instance) and other occasions when you want to pen invitations.

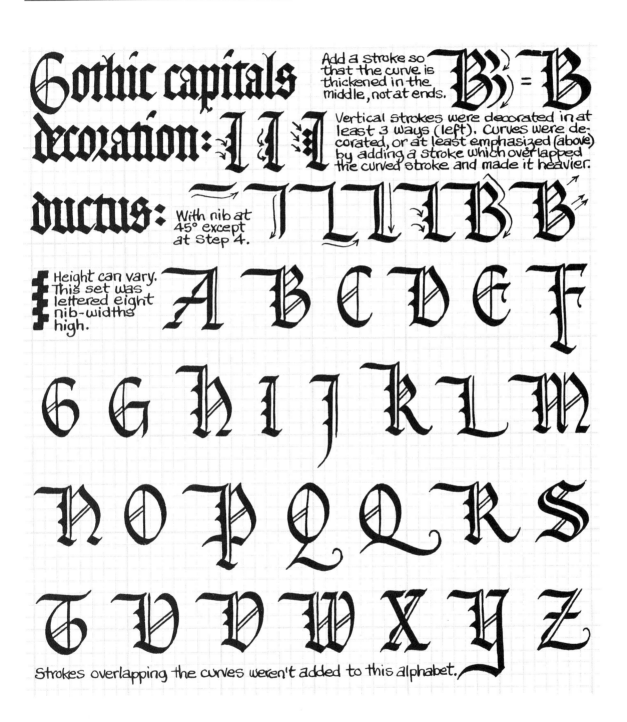

Gothic capitals decoration:

Add a stroke so that the curve is thickened in the middle, not at ends.

Vertical strokes were decorated in at least 3 ways (left). Curves were decorated, or at least emphasized (above) by adding a stroke which overlapped the curved stroke and made it heavier.

ductus:

With nib at 45° except at Step 4.

Height can vary. This set was lettered eight nib-widths high.

A B C D E F
G G H I J K L M
N O P Q Q R S
T U V W X Y Z

Strokes overlapping the curves weren't added to this alphabet.

Gothic Capitals

GLOSSARY

Abecedarian From the Latin, meaning relating to the letters of the alphabet. An abecedarian sentence is one which contains every letter of the alphabet.

Ascender That portion of a letter which rises above the standard or minim height, such as in **b**, **d**, **f**, **h**, and so forth.

Calligraphy A term meaning the art of writing beautifully.

Cursive From the Latin, meaning running; in terms of writing, referring to a version produced quickly, with more concern for speed than appearance. To this end, cursive writing usually involves lifting the nib from the writing surface as infrequently as possible. What we call writing in script today is pure cursive.

Descender That portion of a letter which falls below the standard or minim height, such as in **g**, **j**, **p**, **q**, and **y**.

Ductus A guide to the way letter shapes are formed; it includes knowing in which direction to pen each stroke of a letter and in what sequence the strokes are made.

Fixed pen The technique of lettering in which the nib is held at a single angle throughout any given stroke. A scribe writing in fixed-pen style may change nib angles for different strokes, but not in midstroke.

Folio A sheet of writing material intended as part of a manuscript. Each surface of a folio is divided into two pages and, when folded, constitutes four pages of a manuscript.

Hand The unique appearance of a scribe's writing. While many scribes may write with the same script style in mind, each scribe's handwriting is his own.

Illuminate To paint or color on a page; to create a decoration of any sort. Illuminators were so called, after the eighth century, because their use of gold in decoration caught the light and was said to light up or illuminate the page.

Ligature Two or more letters whose shapes are in any way altered so that they become a single figure. Two adjacent letters

are sometimes connected because the final stroke of one ends where the first stroke of another begins, and, for convenience' sake, the nib is not lifted between strokes. But these are usually not considered ligatures because neither letter's shape is changed to aid the connection.

Majuscule Large letters either with or without very short ascenders and descenders; letters formed with the emphasis on uniform height throughout. Capital letters are majuscules.

Manipulated pen The technique of lettering in which the nib changes its angle one or more times during a single stroke.

Minim A brief, simple, single vertical stroke, such as the one with which **i** is formed, the two forming **n**, or the three forming **m**. Minim height refers to the distance between the highest and lowest level of the minim strokes of an alphabet. This measurement does not include the ascender, which rises above the minim, or the descender, which falls below it.

Minuscule A letter or alphabet of small letters with prominent ascenders and descenders. Our lowercase letters are minuscules.

Model book The scribe's or scriptorium's notebook containing samples of texts and/or standard illustrations to be copied; anything which might be used as a reference in writing or illustrating a manuscript.

Nib The point of a pen, specifically the part that touches the writing surface.

Paleographer A scholar specializing in the study of the history of writing.

Papyrus Writing material produced from crisscrossed strips of the papyrus plant, found most often in wetlands of Egypt. Papyrus was used as writing material from three thousand B.C. or earlier and was rejected in favor of parchment early in the Middle Ages.

Parchment Writing material made from the skins of animals; the process was known to man for many centuries before the Middle Ages. Parchment superseded papyrus in use in early medieval times because it was easier to obtain, stronger, and more lasting.

Pattern book Another term for **Model book**, but instead of text, it contains illustrations meant to be copied or traced in full or in part.

Recto When a folio is inserted in a manuscript, the right-hand page is the recto, and the next page is the verso. While every page in a modern book has a separate number, the recto and verso pages in a medieval manuscript shared the same number. Thus a right-hand page would be folio 17 recto, and the next page folio 17 verso, then folio 18 recto and so forth.

Rubricate From the Latin for red pigment, meaning to color in

red. The large capital letters of decorated medieval manuscripts were most commonly colored in red and blue. In the later Middle Ages when decoration became a specialization, the scribe assigned this task was called a rubricator.

Script An alphabet of a specific design. While different scribes and different scriptoria may have employed slightly different letter shapes, if they were all quite similar they were considered variations of the same script.

Scriptorium The place in which a scribe or group of scribes wrote. In early monasteries this consisted of an area along the walls of a courtyard. It later came to mean a room devoted to the purpose of writing. The plural is scriptoria.

Serif The beginning or end of any stroke that is wider than the width of the stroke itself; a decorative technique to emphasize the beginning and/or end of a stroke, borrowed from the Greeks and perfected by the Romans beginning in the first century B.C.

Stroke Any single movement by the nib on the writing surface.

Stylus The pointed instrument used to scratch lines or letters on the wax surface of tablets or on any surface.

Tablet Usually referring to a wooden form, much like a child's slate, edged with a wooden rim and filled with a thin layer of wax for the purpose of being written upon. Many such tablets, tied together with leather thongs, formed the first "books."

Text block The area of a page covered by writing or print.

Textura From the Latin for woven; referring specifically to the most formal, carefully designed calligraphy of the Gothic period ending the Middle Ages, but in general meaning the most calligraphic form of any writing, that is, the opposite of cursive.

Twist stroke See **Manipulated pen**.

Verso The page following the recto; that is, written on the back side of the recto. See **Recto** and **Folio**.

Writing master A scribe common to the last century of the Middle Ages; one who taught writing and occasionally other basic elementary educational skills, either as a private teacher, a teacher in a school, or an itinerant.

FURTHER READING

Additional information and instruction on medieval calligraphy can be found in two major volumes:

Medieval Calligraphy: Its History and Technique by Marc Drogin; published by Abner Schram Ltd., Montclair, N.J.

The Medieval Scribe: His History and Technique by Marc Drogin; [forthcoming] from Abner Schram Ltd.

Among the many books about calligraphy to be found in libraries and shops, the following are recommended:

Ancient Writing and Its Influence by B. L. Ullman; published by Cooper Square Pubs., Inc., New York.

The Art of Written Forms by Donald M. Anderson; published by Holt, Rinehart & Winston, New York.

A Book of Scripts by Alfred Fairbank; published by Faber & Faber Inc., Salem, N.H.

An Introduction to Greek and Latin Paleography by Edward Maunde Thompson; reprinted by Burt Franklin Publishers, New York.

Lettering by Hermann Degering; a Pentalic Book, published by Taplinger Publishing Co., Inc., New York.

2,000 Years of Calligraphy by Dorothy Miner, Victor I. Carlson, and P. W. Filby; a Pentalic Book published by Taplinger Publishing Co., Inc., New York.

Writing and Illuminating and Lettering by Edward Johnston; a Pentalic Book, published by Taplinger Publishing Co., Inc., New York.